Drawings and Graphics

Jacqueline Morreau, *Series Editor*

1. Martin Wiener, *Taking a Line for a Walk*
2. Sidney Hurwitz, *Etchings*
3. Sue Coe, *Paintings and Drawings*
4. Jacqueline Morreau, *Drawings and Graphics*

Sidney Hurwitz: Etchings

Sidney Hurwitz: Etchings

The Scarecrow Press, Inc.

Metuchen, N.J. & London, 1985

Library of Congress Cataloging in Publication Data

Hurwitz, Sidney, 1932–
 Sidney Hurwitz, etchings.

 1. Hurwitz, Sidney, 1932– --Catalogs. I. Title.
NE2012.H87A4 1985 769.92'4 85–1776
ISBN 0–8108–1791–8

Book design by Alston Purvis

Preface

The artists in this series have all used drawings and graphics in a variety of ways which vary in intention from private meditation, to an instrument of discovery, to a public statement. At one time the word "graphics" was used to describe those arts which were produced by making strokes on flat surfaces, as opposed to those in which materials were wrought or carved or pierced. Later the term was more often applied to works on paper made from an artist's original block, plate, stone, or screen; that is, printed line-cuts, etchings and engravings, lithographs, and silk screens. Most recently, "drawings and graphics" are terms applied to all hand-made *and* mechanical reproduction of images and even to the designing of such pages.

The boundaries are no longer clear, and many artists make images for mechanical reproduction in the same week as they make fine art multiples. And it is often difficult to know where drawing ends and painting begins. I have in these volumes crossed borders freely, and have also included here work which is definitely painting when it gives a clearer picture of the artist's work.

Representational art is once again at the center of the art world and its debates. We find that artists and commentators, whose ideas were formulated in the postwar years, fear this new wave of figurative art as being inevitably regressive. Other people hope that it will be a more comfortable approach to art—they may hope that artists will go back to "painting what they see" and stop being difficult. Both believe that representation is a step into the past.

This cannot be. The two factors which characterize the art of the 'eighties, and particularly feminist and overtly political art are, first, *content,* and

second, the diversity of styles through which that content is expressed. Artists have been borrowing from old styles and inventing new ones in order to strengthen the communication of their content.

Today's artists have reclaimed the whole vocabulary of visual languages with which to make new meanings. Many have an increased awareness of the responsibility visual representations carry. They do not believe, as artists once could, that art can be neutral. "All art is political," could be the watchword of the day. All art carries meaning within its form and within its content; nor can form and content be separated.

These were some of the considerations I had in mind when choosing work for this series. In each volume, I have tried to show the work of an artist who has developed a particular language with which to express a personal understanding of the world in which she or he lives.

Many American artists have come to work in London. For them it can be amazingly lively. Even the decay of pavements, buildings, industrial sites, can seem part of the process of life itself. It is not surprising that Sidney Hurwitz began his series of prints, which are akin to industrial archeology, in London. Here is a pleasure in the machine, and its organic change, and a relief that these changes are visible, not hidden.

It is often the stranger who sees those wonders of the environment that the natives have learned to devalue or ignore entirely. The delight which Hurwitz reveals when he depicts urban artifacts has often communicated itself to the viewers and has led them to look again at those structures from which they had previously averted their eyes.

Two somewhat conflicting emotions are communicated in the work. The first, as I've said, the delight, not only in the shapes and forms themselves, but in the human ingenuity which went into the invention and use of all those tunnels, tracks, machines, towers—technology which is still connected to the human use and the human scale. Perhaps the most important aesthetic legacy of the last century was this one. Of course those who founded the Bauhaus in 1919 were aware of this, but Hurwitz has made it real for us again. The second emotion central to the work is melancholy—the objects are invested with a poignancy such as we feel when looking at the frail and ephemeral human form.

For unlike the Russian Constructivists and some American and European artists who celebrated the machine, seeing in it a future of order, equality,

work and reward, Sidney Hurwitz' pictures have been made at the end of the machine age, and seem to look back on it with some degree of regret and nostalgia. The constructions and mechanisms he shows us are dying, some have already gone in the few years since Hurwitz drew them.

The strong tactile presence of the work on the page is also extremely important in the etchings. For us in the 1980s it is important to realize how consciously artists combine concern with the page itself and the representation it carries. I cannot imagine this work having such a strong impact in another medium.

JACQUELINE MORREAU London 1984

Foreword

SIDNEY HURWITZ shares a vision which seems to me cool, detached, intellectual, analytical. He expresses his observations along the Thames in images of strength and symbols of labor, from cranes pointing upward into the sky to burly, big-shouldered warehouses. Even ropes that dangle from wharves suggest the workers we never see. We contemplate the frequent emptiness of the dockside world, a built world except for the tidal river indicated in some of his pictures as a line, like a horizon line (the bottom horizon) and a tone.

We are free to bring with us our own store of memories and associations. We can add, if we will, the salty stench of tidal river, and some of the colors of this particular setting: the gray of weathered wooden pilings, the brown rust of metal warehouse doors, the dark grime overlaying brick walls, the paint or rust on the surface of machinery. We can add the sounds, the suck of the tide, the rap of a halyard against a mast, if halyard or mast survive in this setting for machines. We can add silence, but probably not for long, for it is rare, today, to be out of the sound of the internal combustion engine, blasting its way into our meditations from a huge jet-propelled airplane overhead or a hovercraft moving up or down the river.

Hurwitz has returned to the old medium of aquatint, and lives dangerously by practising it on large copperplates, sixteen by twenty inches to twenty by twenty-four. The transparent tones of aquatint he uses to depict a world in which docks, machines, and buildings testify to human activity intense but unseen, a world full of geometry and pattern. With his range of tone and the white of the paper, and black/brown ink, he can move from

blinding sunlight on walls to depths of shadow, and to the shadows traced by ropes or cranes.

Engineering fascinates him. In London and Boston he shows us, in detail, complex bridge machinery and interweaving oil pipes and the steel framework of automobile expressways.

Much as I enjoy his aquatint views of the Norfolk countryside, another subject appearing here, I hope he will extend his explorations of the world of oil storage terminals, construction sites, warehouses, bridges, and tunnels.

Other readers of this book may share my gratitude for reproductions which indicate what Hurwitz is doing, even though, as probably goes without saying, you must see the big aquatints to appreciate their beauty as pictures. The reproductions condense and solidify, emphasizing design; they perform a welcome service, but only as an introduction to the original prints.

SINCLAIR HITCHINGS Keeper of Prints Boston Public Library September 1984

Introduction

THE PRINTS AND DRAWINGS reproduced in this volume are representative of the major portion of my work from 1973 to the present. They deal primarily with images derived from man-made sources—factories, warehouses, bridges, roadways, tanks, pipes and other forms of urban and industrial architecture.

While I have made prints since the earliest years of my art school training, they have for the most part been concerned with figurative or more conventional landscape themes. It was not until I spent most of 1972-73 working in printmaking studios in London that my interest turned to the built environment as a source of imagery. The architectural aspects of the city—particularly the 19th century industrial structures which remain so much a part of that city—became the central focus of my prints.

Upon my return to the United States I continued to seek and find a rich source of material in my own environment. The interplay of light and shade on the geometric volumes of pipes, tanks, and buildings hold for me unceasing and endlessly varied possibilities for graphic expression. There are in these purpose-built structures a logic of form and unpredictability of variation which surpasses that of most sculpture which attempts to deal with abstract geometric form.

The medium of etching on metal plates is, I find, a most satisfyingly appropriate way in which to describe the rich textures of corroded steel, concrete slabs, corrugated iron and other building materials. The bitten plate lends itself perfectly to the need to render the line and tone of complex

precision found in this subject. The clear grays and rich blacks of aquatint are for me the ideal means with which to express light and shade.

In dealing with this imagery I am constantly mindful of those artists of the past who have made this subject part of a rich tradition. One thinks of Leonardo da Vinci rendering in exquisite form his complex inventions, Piranesi's architectural fantasies, and among the more recent traditions the Italian Futurists who found in industrial forms the spirit of Modernism. Such artists as Léger, Duchamp, The Russian Constructivists, The Americans Sheeler, Demuth, O'Keeffe, are among my illustrious predecessors whose works reflect the portrait, landscape and still life of the industrial age.

SIDNEY HURWITZ Wellfleet, Massachusetts July 1984

Illustrations

1 Cityscape, London
2 Blackfriars Bridge
3 Highbury Station
4 Warehouses, Hackney
5 Whitechapel Station
6 Martello Street Arches
7 Chimneys, Barnsbury
8 Rooftops, Barnsbury
9 Gantry Cranes, Thames
10 Thames Barge
11 Thames Series I, Chelsea Flour Mills
12 Thames Series II, Power Station
13 Thames Series III, Refinery
14 Thames Series IV, Doors
15 Thames Series V, Shadows
16 Thames Series VI, Barges
17 Thames Series VII, Warehouses
18 Study for Thames Series VIII, Chimney
19 Thames Series VIII, Chimney
20 Thames Series IX, Ventilators
21 Thames Series X, Coal Ship, Battersea
22 Fort Point Channel Bridge I
23 Fort Point Channel Bridge II

24 Fort Point Channel Bridge III

25 Red Bridge

26 Central Artery

27 Coal Dock

28 Fence

29 Study for Windows

30 Windows, Chemical Plant

31 Study for Shadows

32 Shadows

33 Compressor I

34 Boiler, Oil Terminal

35 Cylinders, Oil Terminal

36 Compressor II, Oil Terminal

37 Tee, Oil Terminal

38 Pipe Junction, Oil Terminal

39 Tanks, Oil Terminal

40 Carburetor—Two Views

41 Plumbing

42 Steel Work

43 Wood Forms

44 Crane

45 Sheathing

46 Superstructure

47 Skylights

48 Grand Rapids

49 Black Facade

50 Stacks

51 Coupling

52 Quarry

53 Concrete Plant

54 Weymouth I

55 Weymouth II

56 Barns, Norfolk

57 Church, Norfolk

58 Near Burnham, Norfolk

59 Three Trees, Norfolk

60 Yellow Field, Norfolk

61 Lungarno Soderini, Florence

62 San Frediano, Florence

63 Rooftops

64 Station Street

65 Rooftops, Chimneys

66 Roofscape, New York

67 Roofscape, Water Tank

68 Roofscape, New York II

69 Brooklyn Bridge Arches

70 Storage Tanks

Sidney Hurwitz: Etchings

1

Cityscape, London

Intaglio, 1973, 11″ x 10″

The first etchings done in London in 1973 were executed at Islington Studios in North London under the proprietorship of Hugh Stoneman. My first responses to the cityscape of London suggest the simplified geometry of shape, line, and value characteristic of my earlier prints.

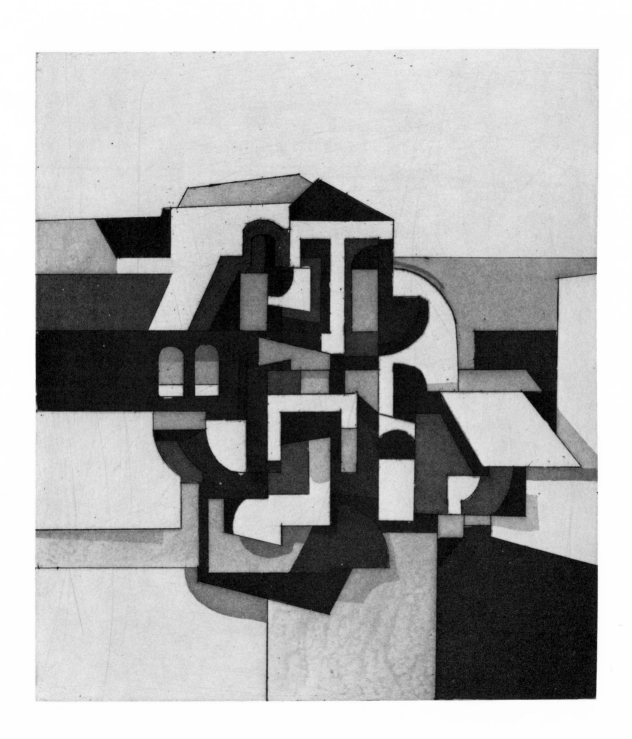

2

Blackfriars Bridge

Intaglio, 1973, 10″ x 12″

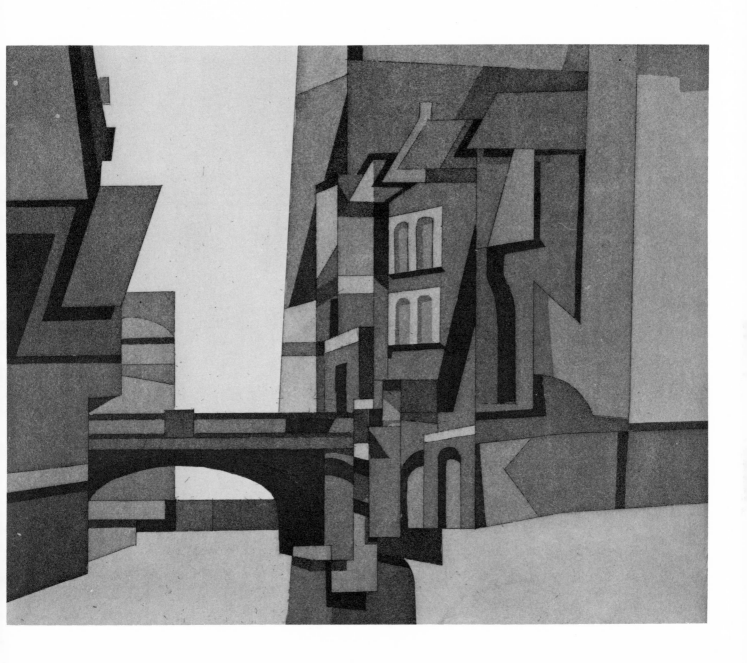

3

Highbury Station

Intaglio, 1973, 14″ x 16″

This print, done from a nearby train station, was the first in this series to reveal more detailed information than is seen in the preceding cityscapes.

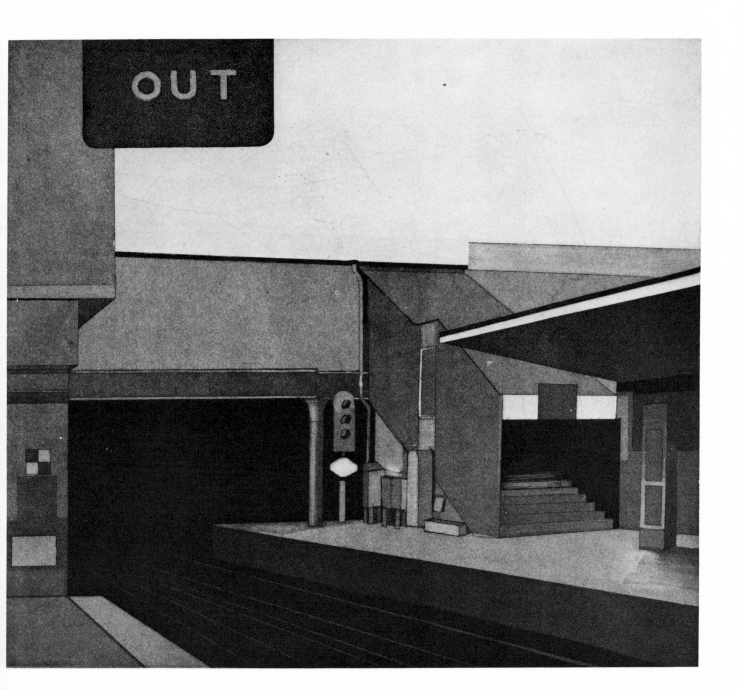

4

Warehouses, Hackney

Intaglio, 1973, 10″ x 11″

This small print utilized very deeply bitten areas of the plate to suggest the depth of architectural planes and the varied textures of building surfaces.

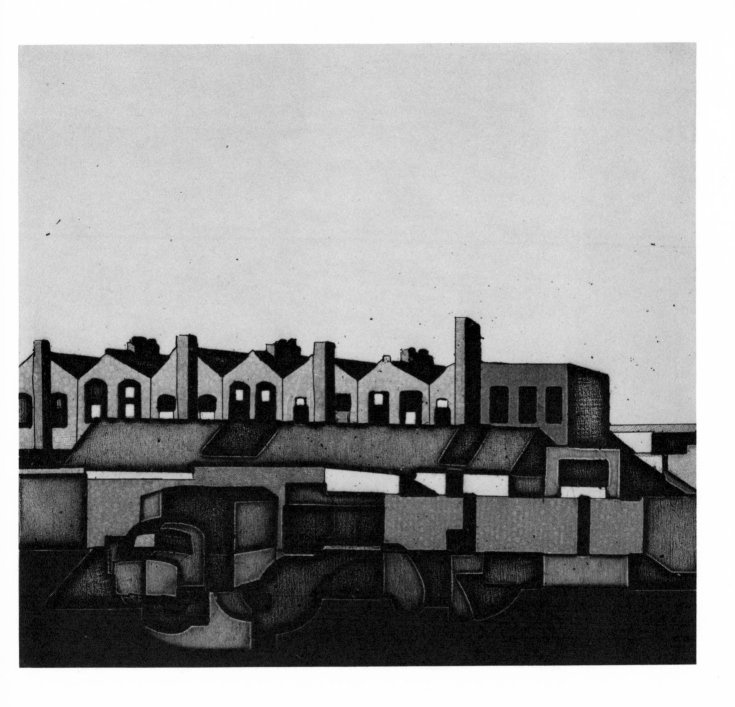

5

Whitechapel Station

Intaglio, 1973, 16″ x 22″

As seen in this print and in Plate 6, I became interested in depicting tunnels, passageways, and arches. Railway architecture is a vital and ubiquitous part of the London cityscape.

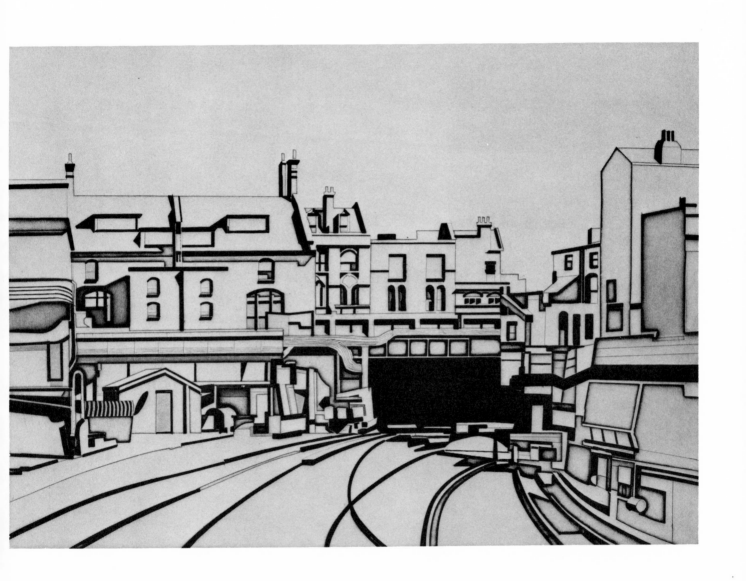

6

Martello Street Arches

Intaglio, 1973, 12″ x 16″

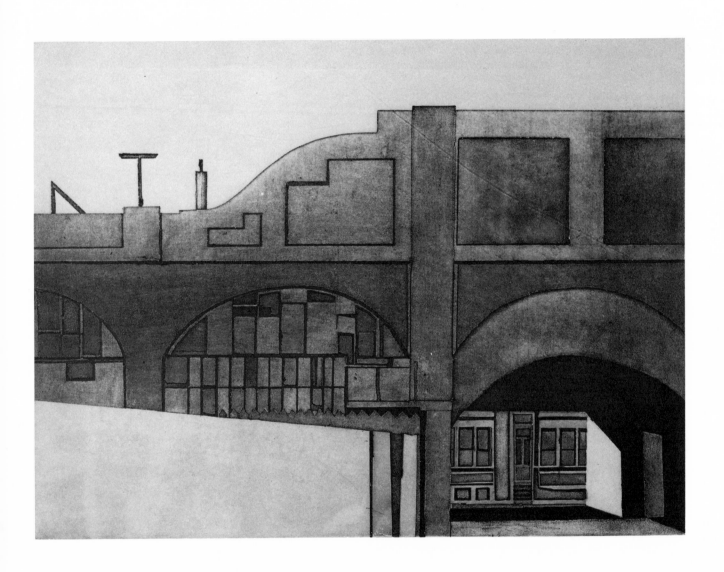

7

Chimneys, Barnsbury

Intaglio, 1973, 9″ x 13″

This was a partially dismantled building showing the interesting masonry of the double-arched chimneys exposed by the removal of the roof.

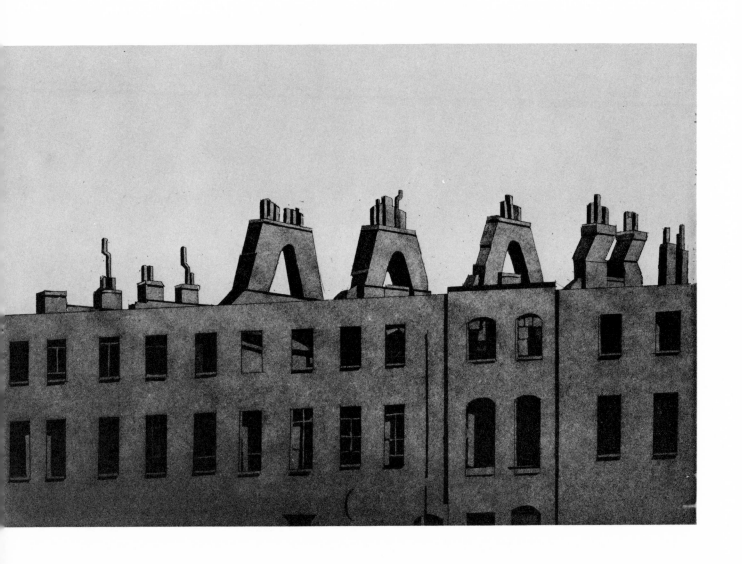

8

Rooftops, Barnsbury

Intaglio, 1974, 9″ x 13″

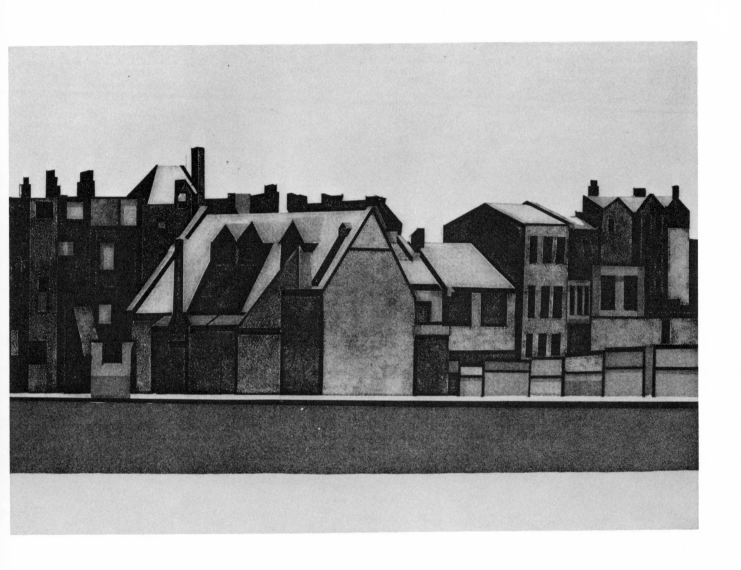

9

Gantry Cranes, Thames

Intaglio, 1975, 11″ x 16″

During my extended stay in London I became interested in the Thames embankment—particularly the docks, warehouses, and industrial aspects of this vital waterway which was and remains the heart and soul of London. This great river has provided a source of inspiration for so many artists including Canaletto, Turner, Monet, Kokoschka, Whistler among many. I began to explore the possibilities of my own Thames series. Plates 9 and 10 are the first efforts in that direction.

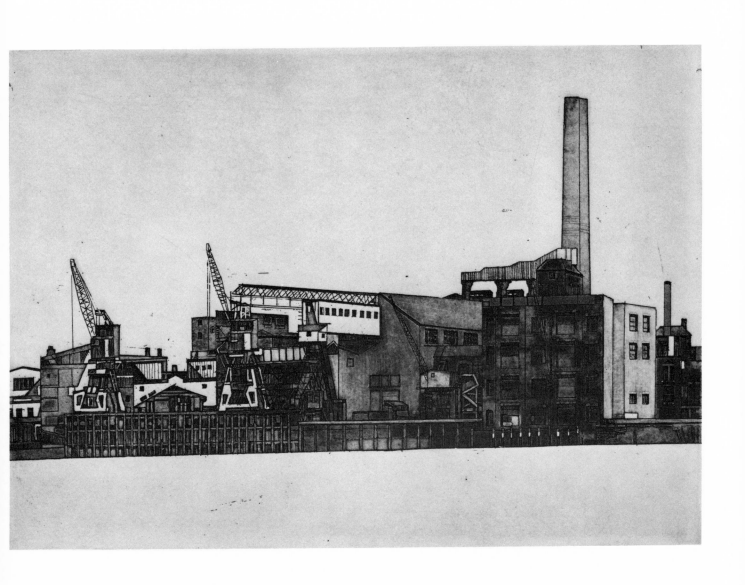

10

Thames Barge

Intaglio, 1975, 13″ x 17″

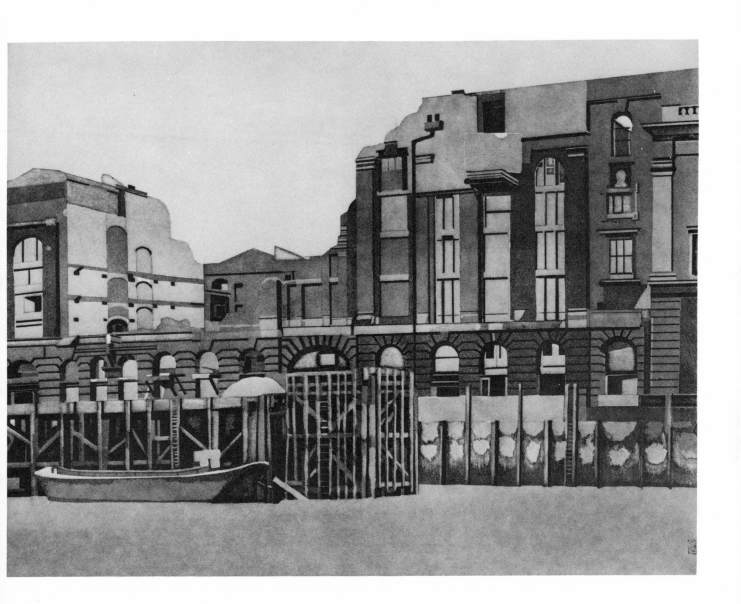

11

Thames Series I, Chelsea Flour Mills

Intaglio, 1975, 24″ x 20″

I returned to London in 1975 to gather material for what was to become a series of 10 etchings based on the industrial aspects of the River Thames. Material for these plates was gathered on foot as well as from the numerous tour boats leaving from Westminster to Greenwich down river or upstream to Richmond.

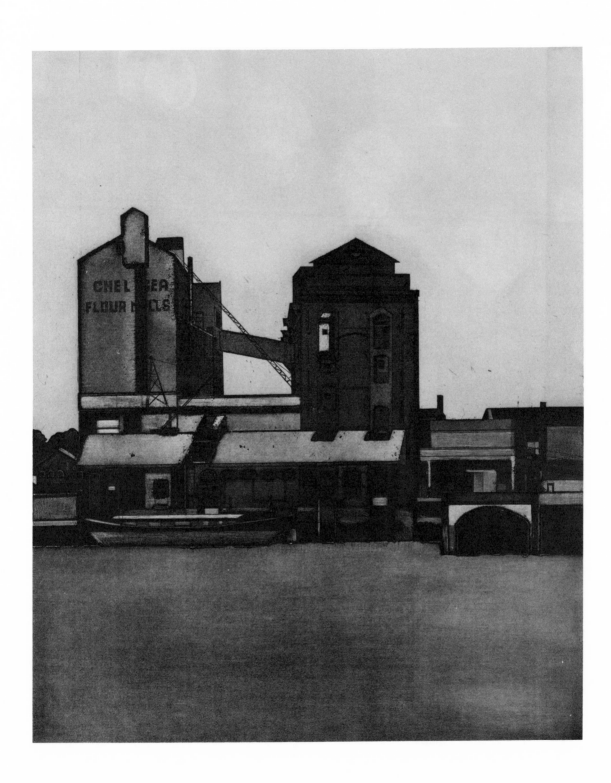

12

Thames Series II, Power Station

Intaglio, 1975, 20″ x 24″

Like so many structures seen in these prints this impressive piece
of architecture has since given way to urban renewal.

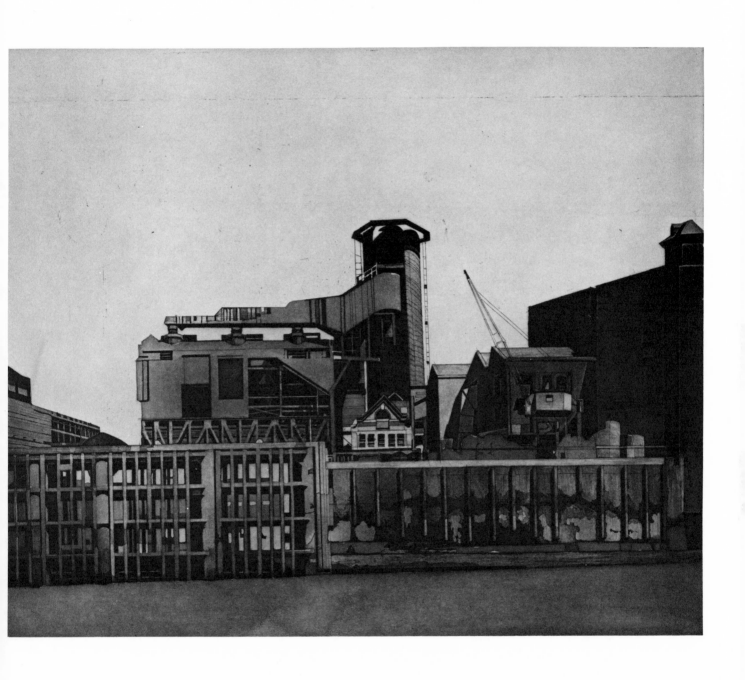

13

Thames Series III, Refinery

Intaglio, 1976, 20″ x 24″

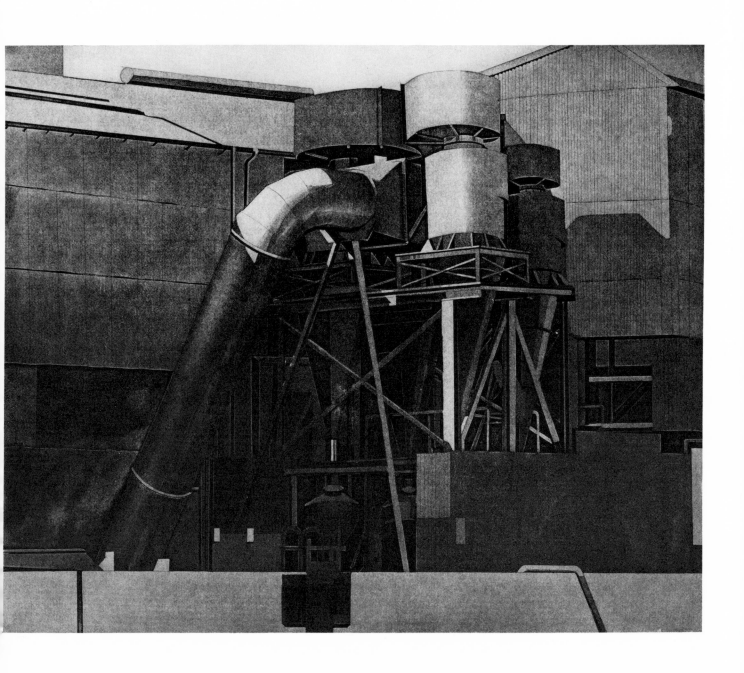

14

Thames Series IV, Doors
Intaglio, 1976, 20″ x 24″

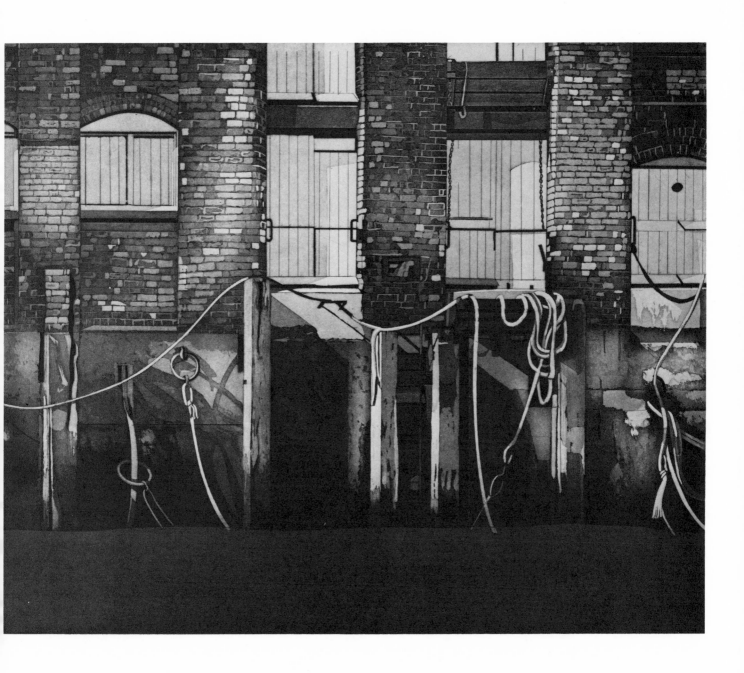

15

Thames Series V, Shadows
Intaglio, 1976, 20″ x 24″

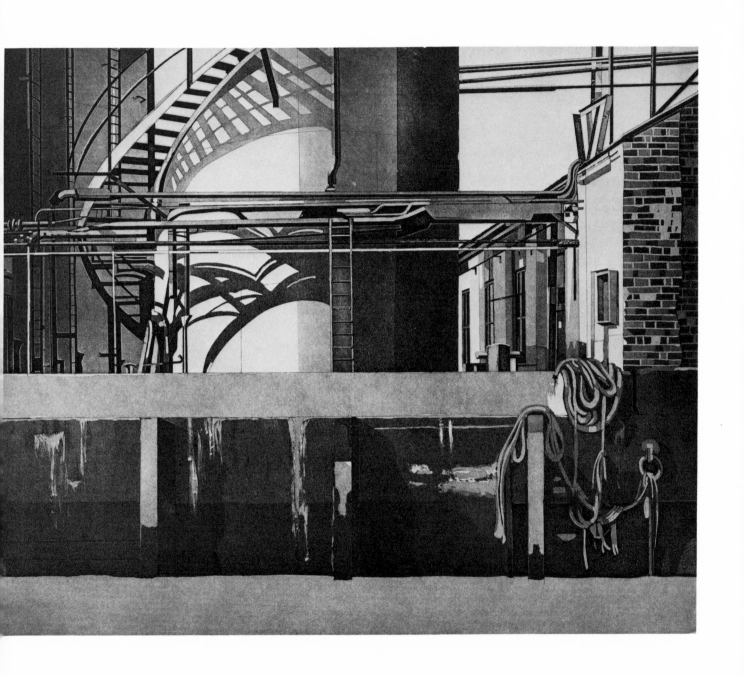

16

Thames Series VI, Barges
Intaglio, 1976, 20″ x 24″

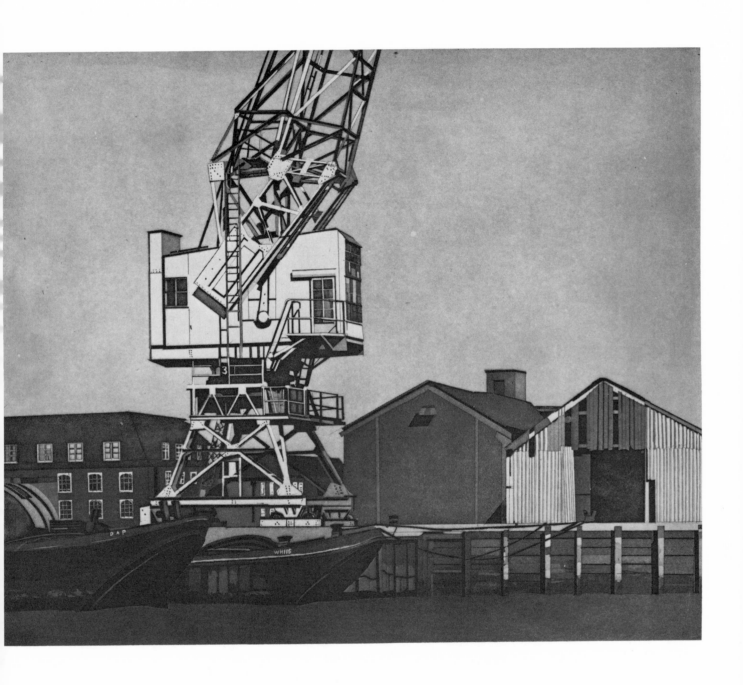

17

Thames Series VII, Warehouses
Intaglio, 1976, 20″ x 24″

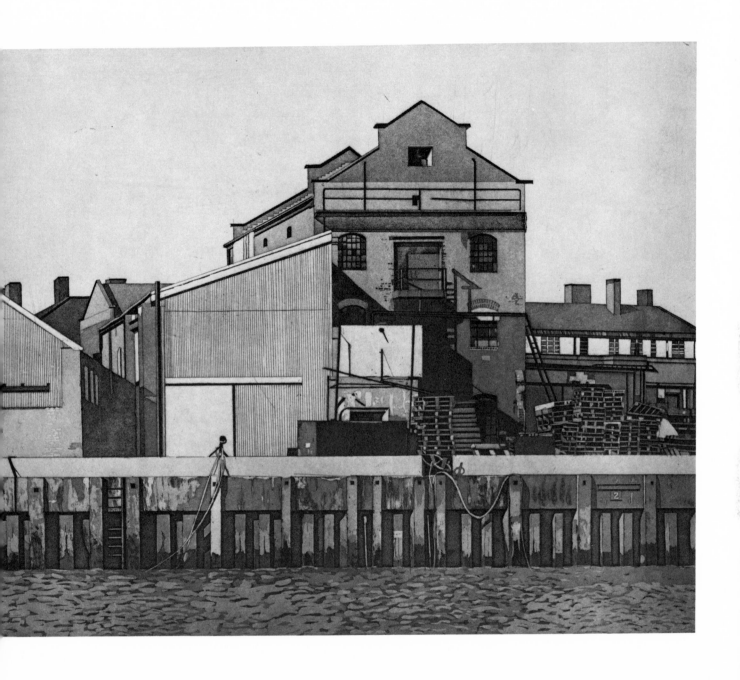

18

Study for Thames Series VIII, Chimney

Acrylic wash, conté crayon, 1976, 24″ x 30″

A number of the Thames series etchings were preceded by crayon/wash drawings of which this is an example.

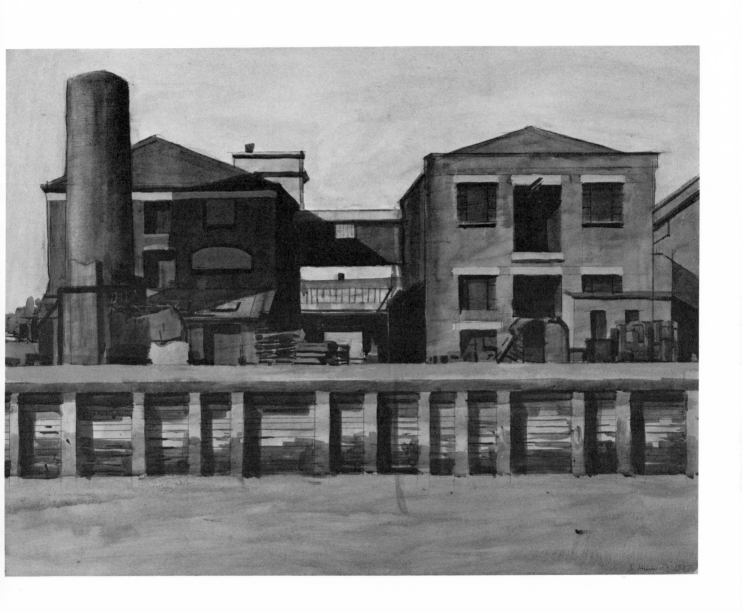

19

Thames Series VIII, Chimney

Intaglio, 1976, 20″ x 24″

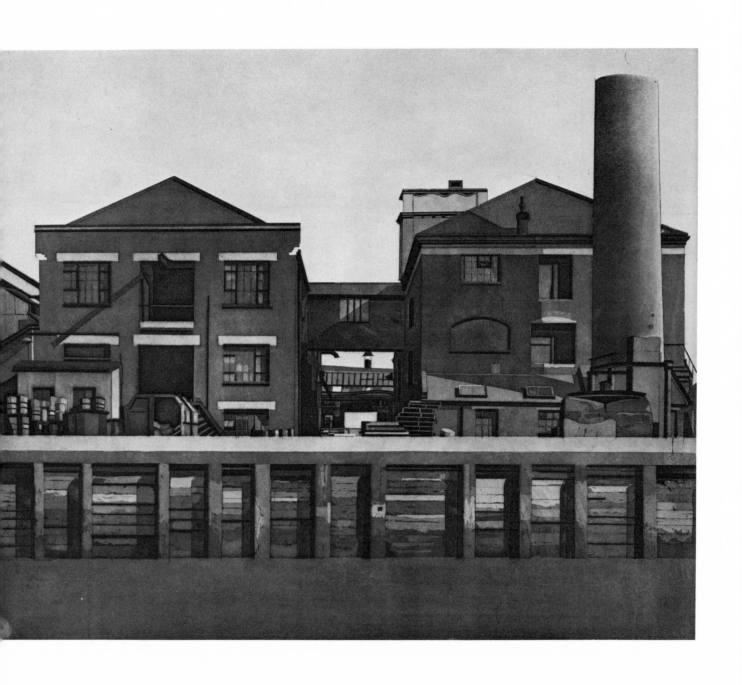

20

Thames Series IX, Ventilators

Intaglio, 1976, 24″ x 20″

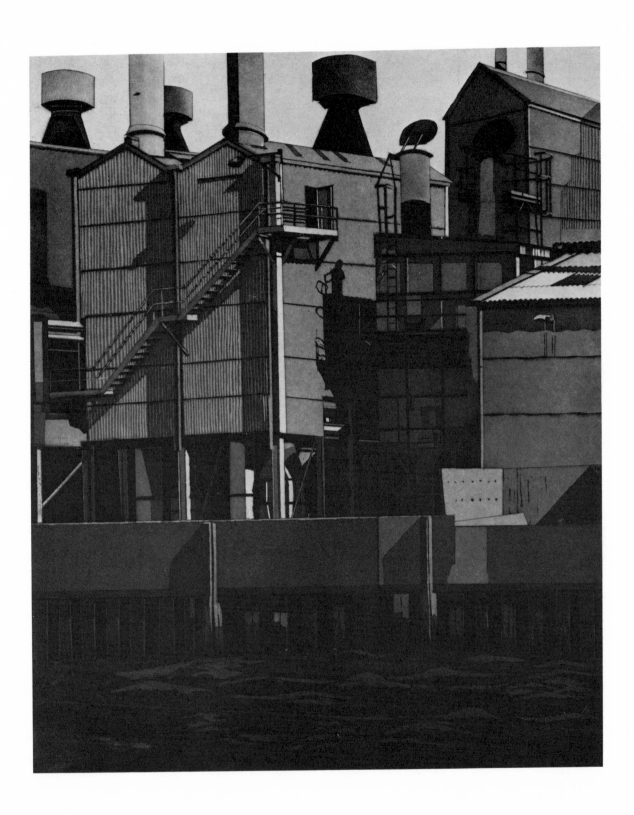

21

Thames Series X, Coal Ship, Battersea
Intaglio, 1976, 24″ x 20″

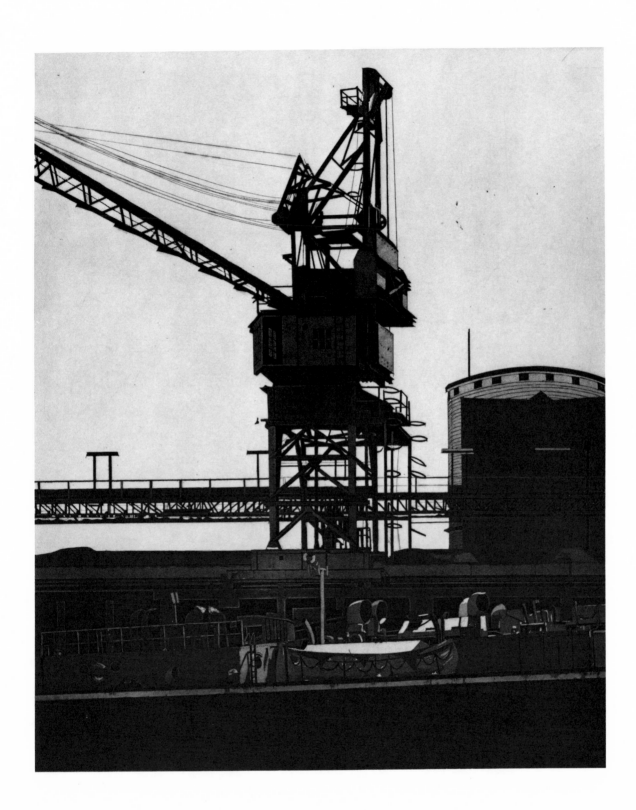

22

Fort Point Channel Bridge I

Intaglio, 1976, 18″ x 24″

Since becoming familiar with Boston in the early 1950s I had been drawn to this fascinating example of railway engineering—the triple bascule bridge over the Fort Point Channel. It was only when I had begun the Thames etchings in 1975 that I felt I had found an appropriate means of expressing my interest in this structure. This and Plates 23 and 24 were the result. Each view is done from a progressively closer vantage point.

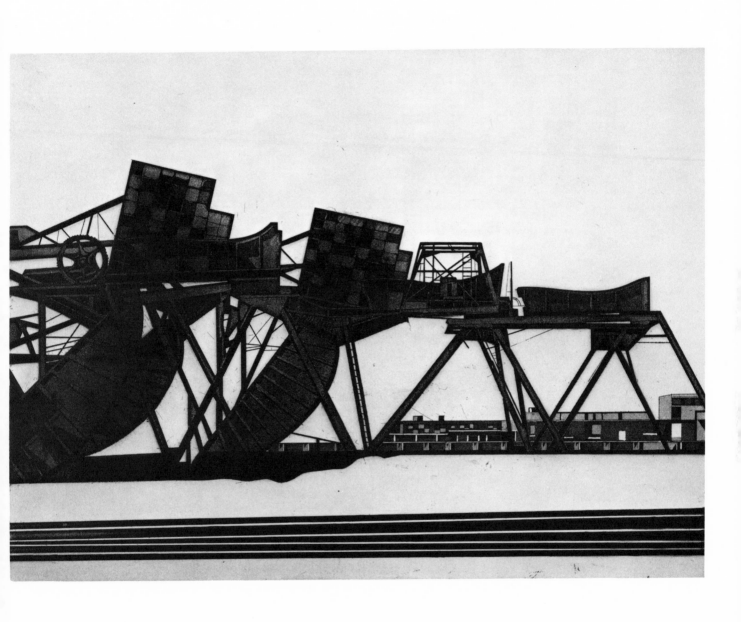

23

Fort Point Channel Bridge II

Intaglio, 1977, 18″ x 24″

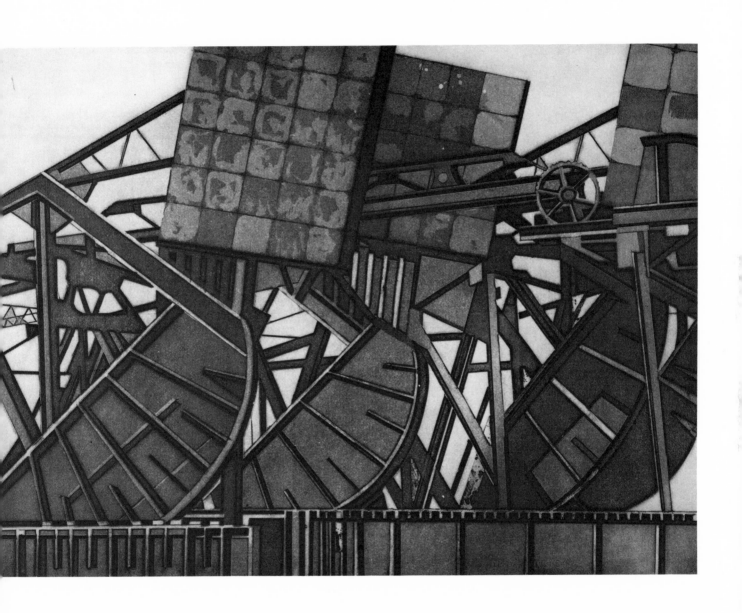

24

Fort Point Channel Bridge III

Intaglio, 1977, 18″ x 24″

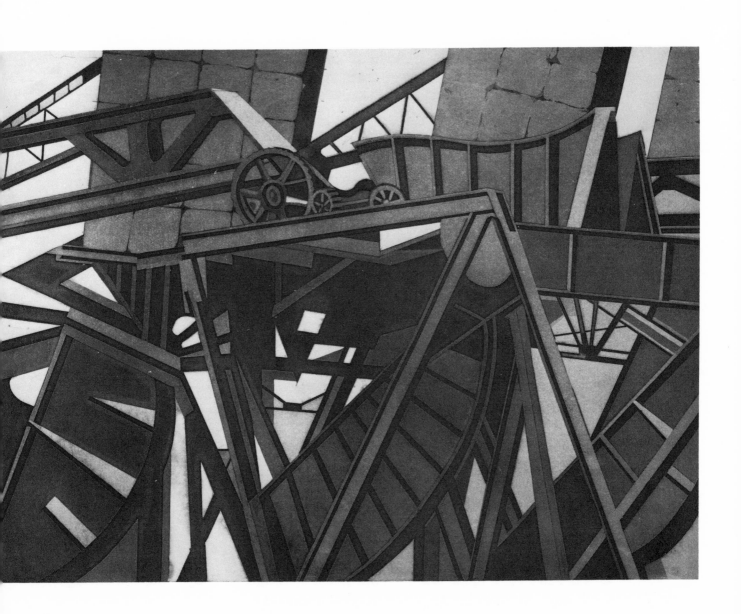

25

Red Bridge

Intaglio, 1980 18″ x 24″

Three years following the completion of the Fort Point Channel series I returned to the subject with this etching of a lift bridge over the same channel.

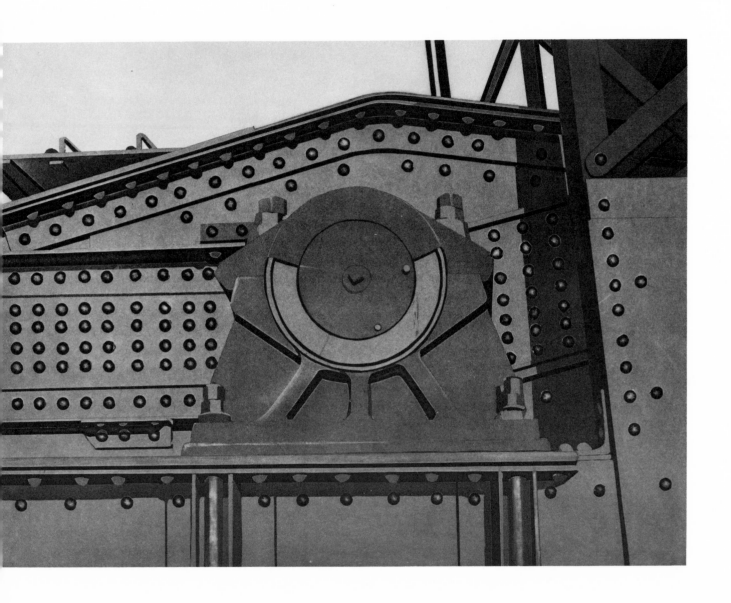

26

Central Artery

Intaglio, 1984, 18″ x 24″

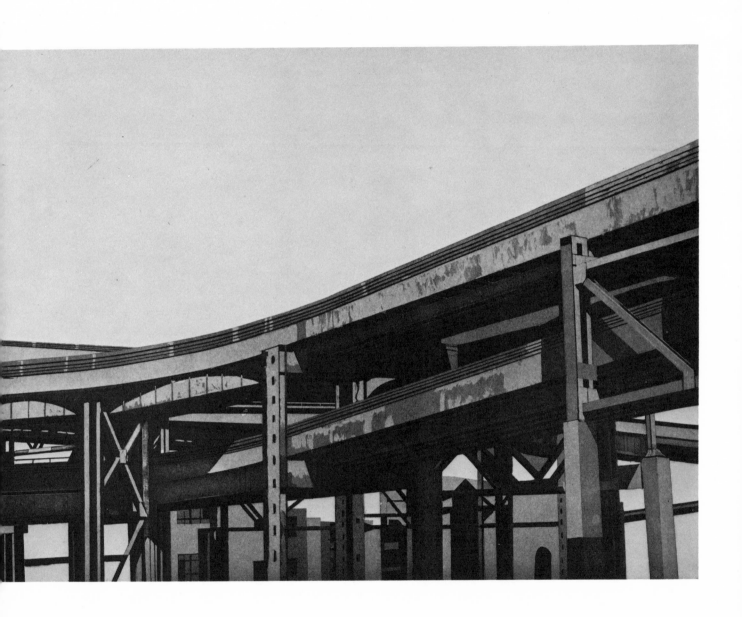

27

Coal Dock

Intaglio, 1978, 24″ x 20″

This timbered structure on the Boston water-front served for many years as a coal storage facility for a power plant. As is the case with many of these structures shown in my work, it has become a victim of development and no longer exists.

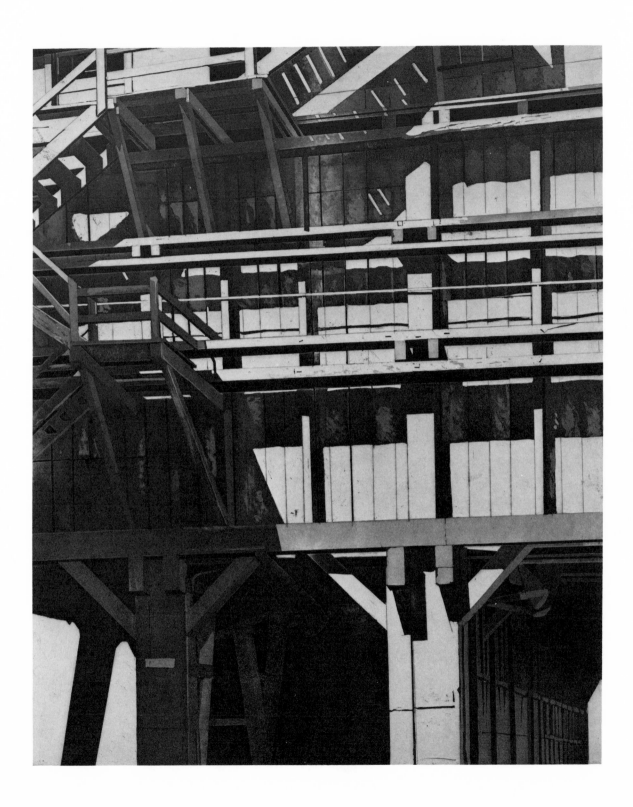

28

Fence

Intaglio, 1978, 24″ x 18″

Plates 28 through 32 are a series of prints done from a chemical plant in Cambridge, Massachusetts.

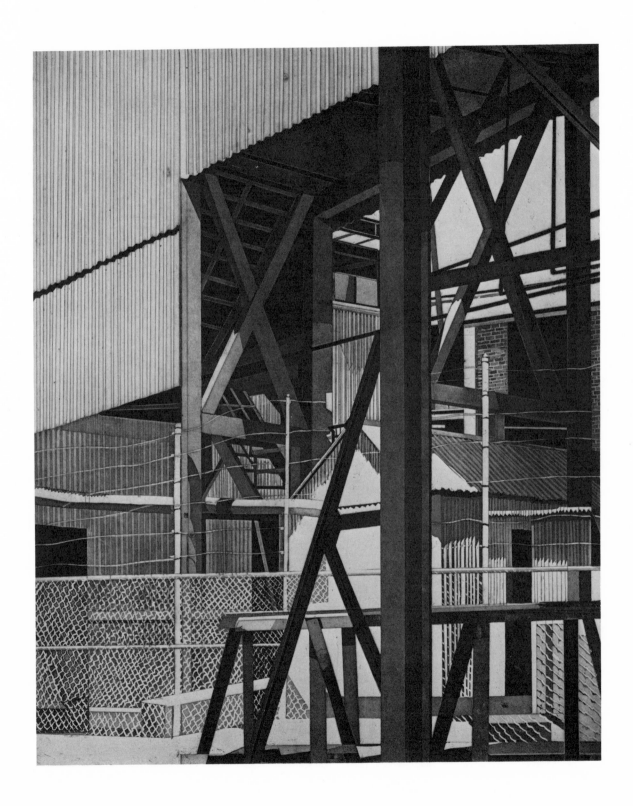

29

Study for Windows

Acrylic wash, conté crayon, 1978, 30″ x 22″

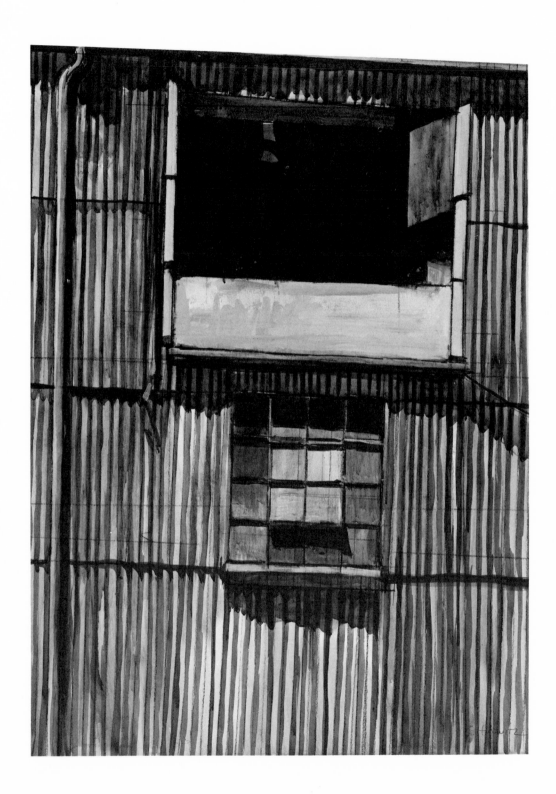

30

Windows, Chemical Plant

Intaglio, 1978, 16″ x 22″

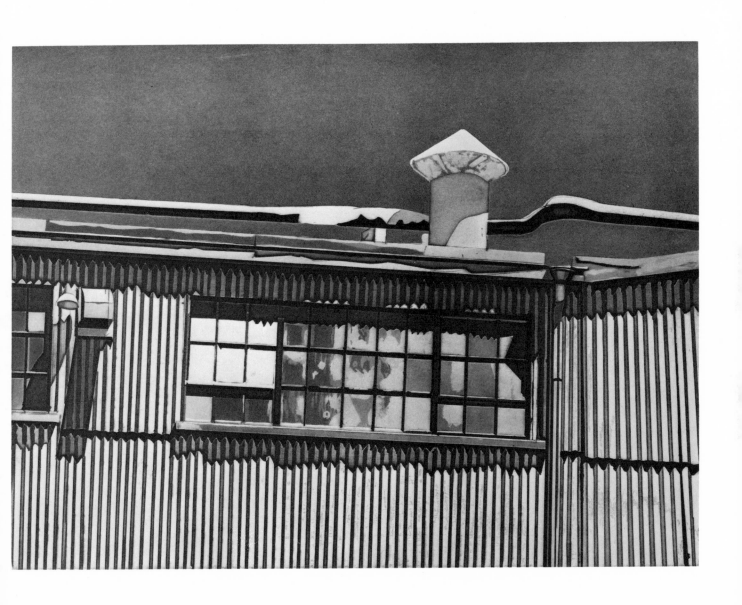

31

Study for Shadows

Acrylic wash, conté crayon, 1978, 22″ x 30″

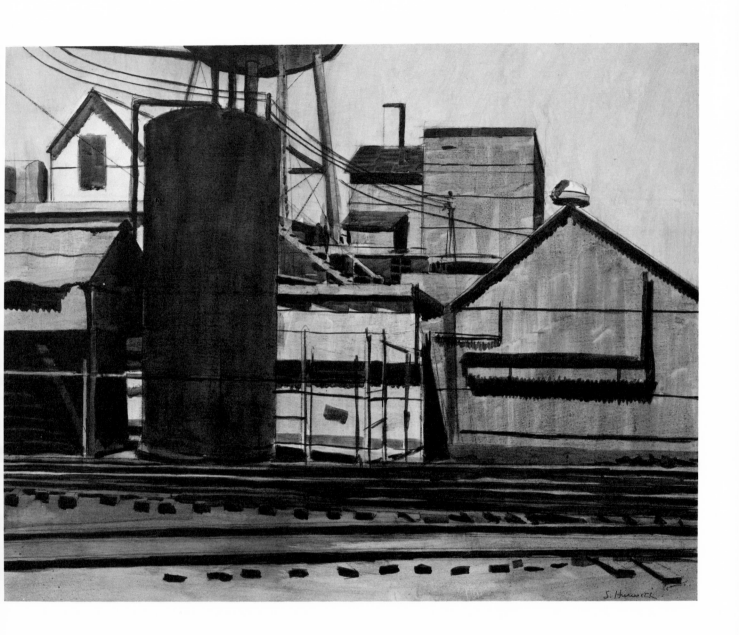

32

Shadows

Intaglio, 1978, 18″ x 24″

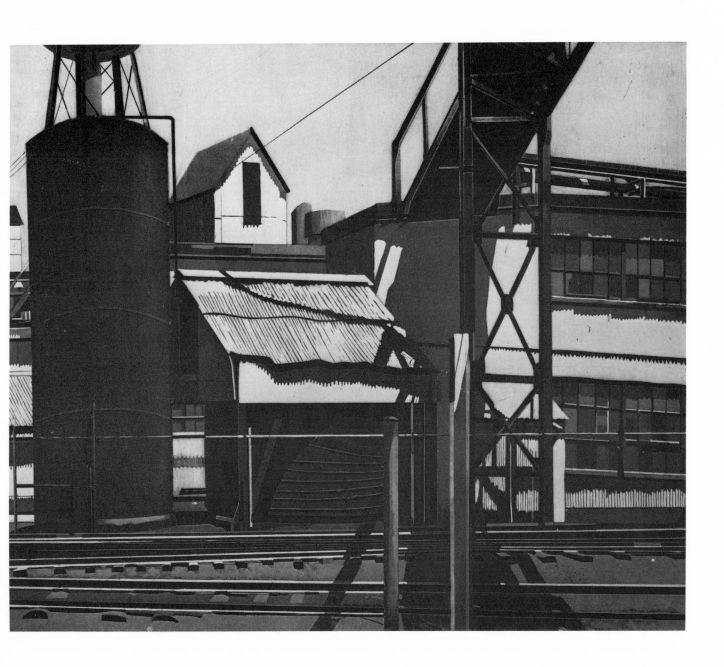

33

Compressor I

Intaglio, 1979, 18″ x 24″

In 1979 I made a series of seven etchings done from an oil and natural gas terminal facility near Boston. The intricate forms of pipes, tanks, ducts and boilers provided a wealth of material.

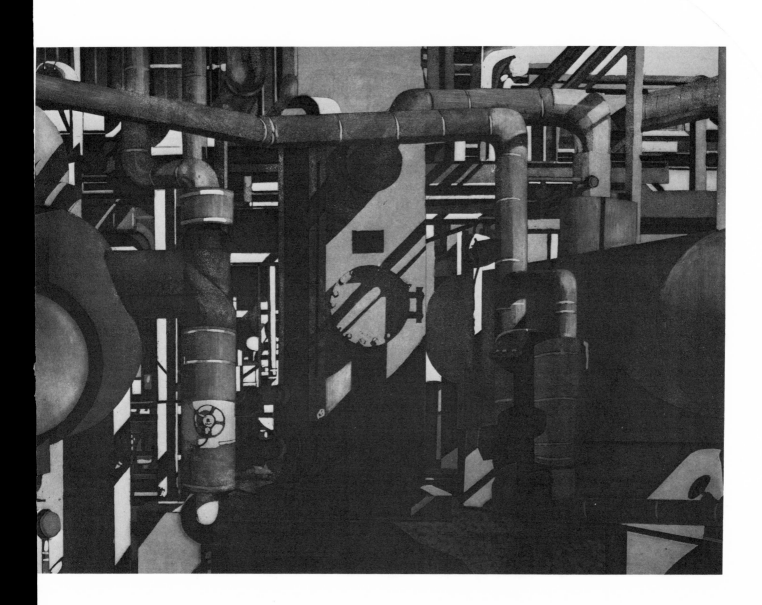

34

Boiler, Oil Terminal
Intaglio, 1979, 18″ x 24″

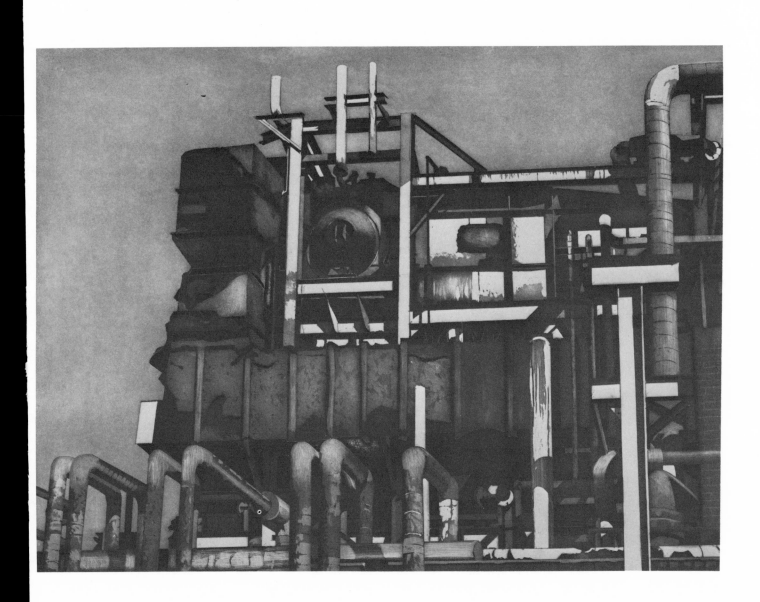

35

Cylinders, Oil Terminal
Intaglio, 1979, 24″ x 18″

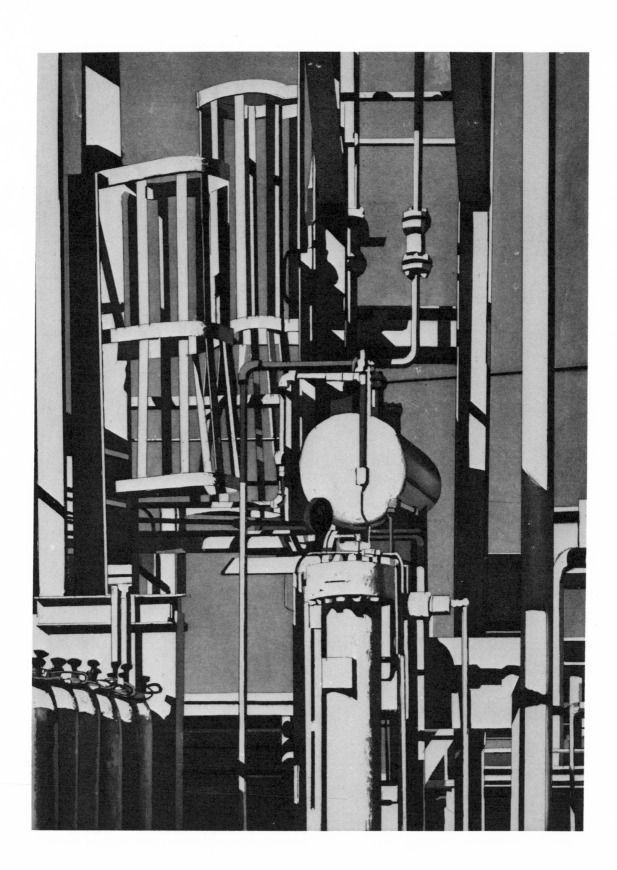

36

Compressor II, Oil Terminal

Intaglio, 1979, 16″ x 22″

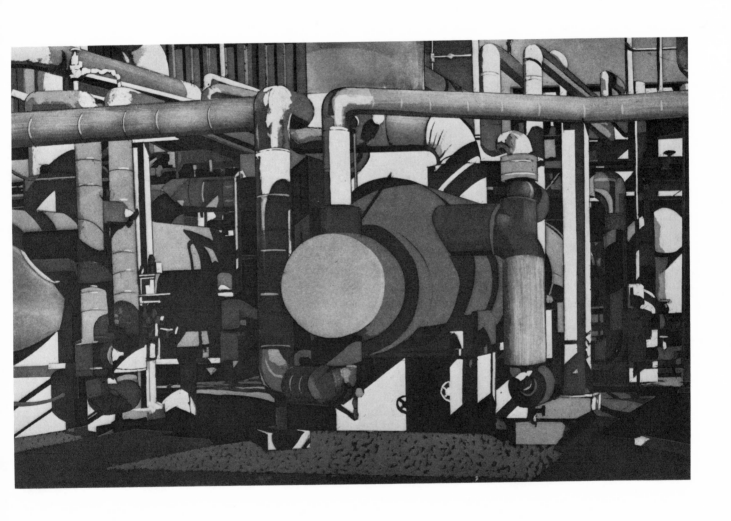

37

Tee, Oil Terminal

Intaglio, 1979, 18″ x 24″

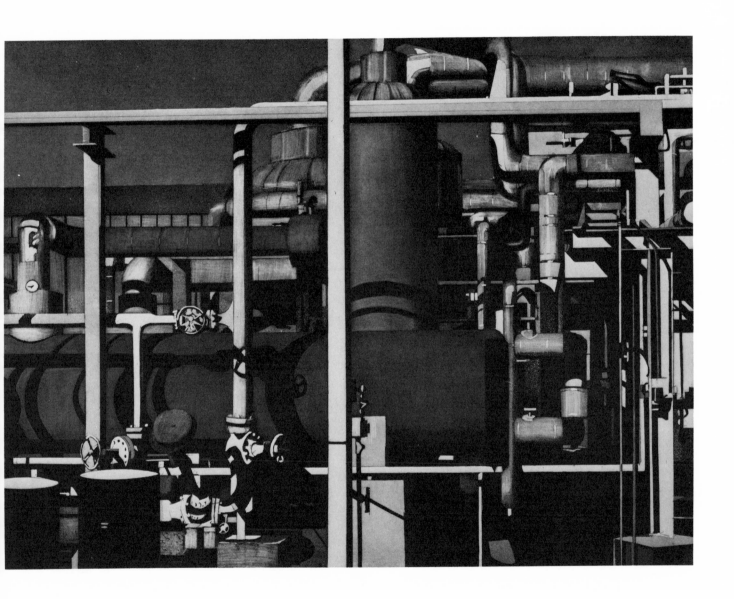

38

Pipe Junction, Oil Terminal
Intaglio, 1979, 16″ x 22″

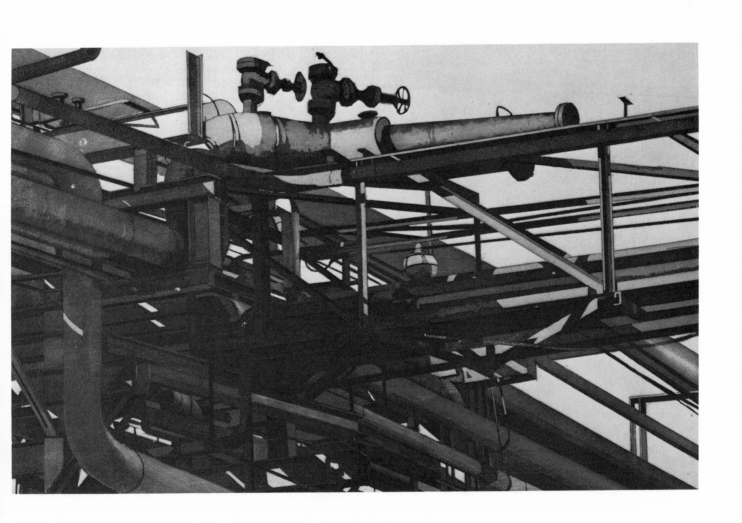

39

Tanks, Oil Terminal

Intaglio, 1980, 16″ x 22″

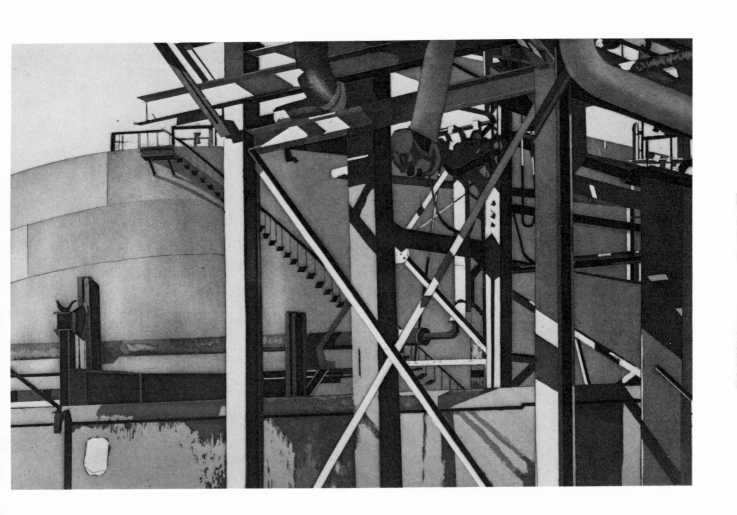

40

Carburetor—Two Views

Intaglio, 1981, 12″ x 20″

The urge to change scale of objects from that of industrial architecture to something of a more intimate size coincided happily with the necessity for the carburetor in my car to be replaced, resulting in two views of this heart of the internal combustion engine.

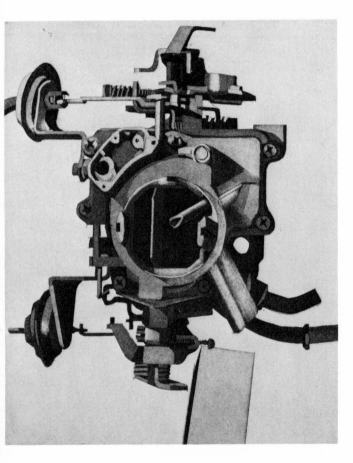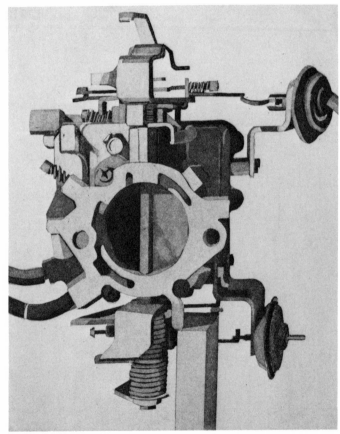

41

Plumbing

Intaglio, 1981, 12″ x 16″

Plates 41 through 47 comprise a series of prints commissioned by the magazine, *Building Construction and Design,* dealing with aspects and materials of the construction industry.

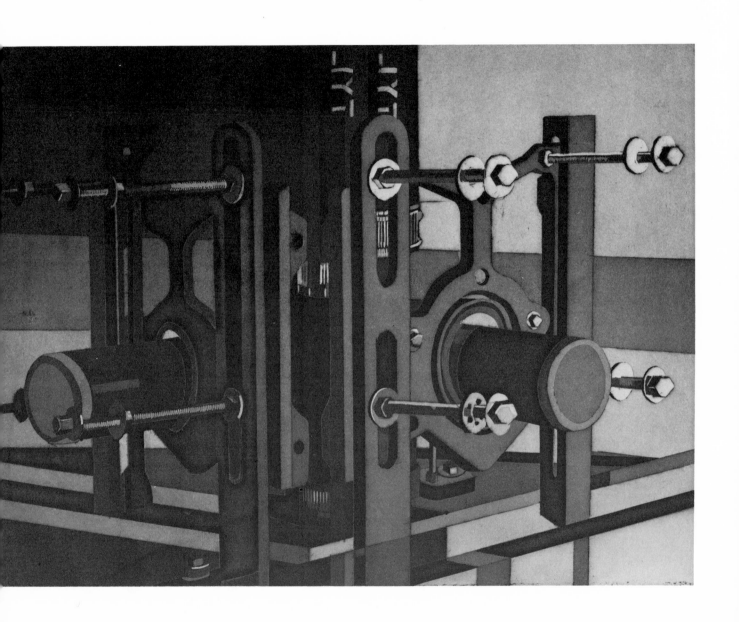

42

Steel Work

Intaglio, 1981, 12″ x 16″

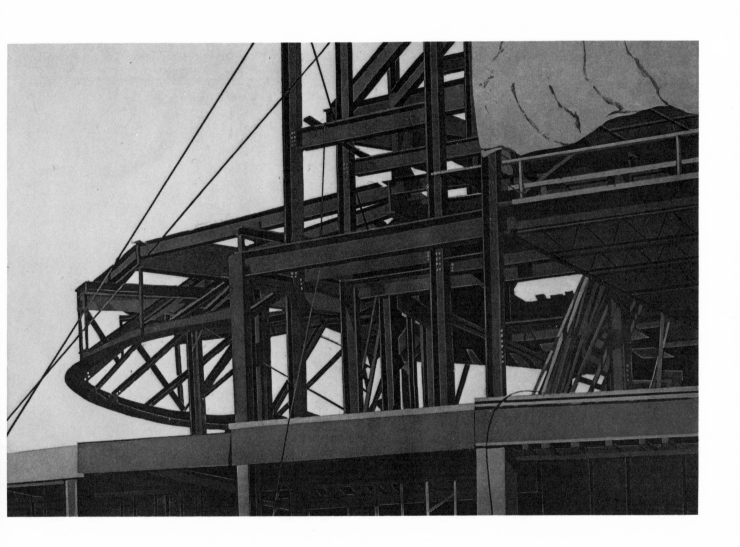

43

Wood Forms

Intaglio, 1981, 24″ x 18″

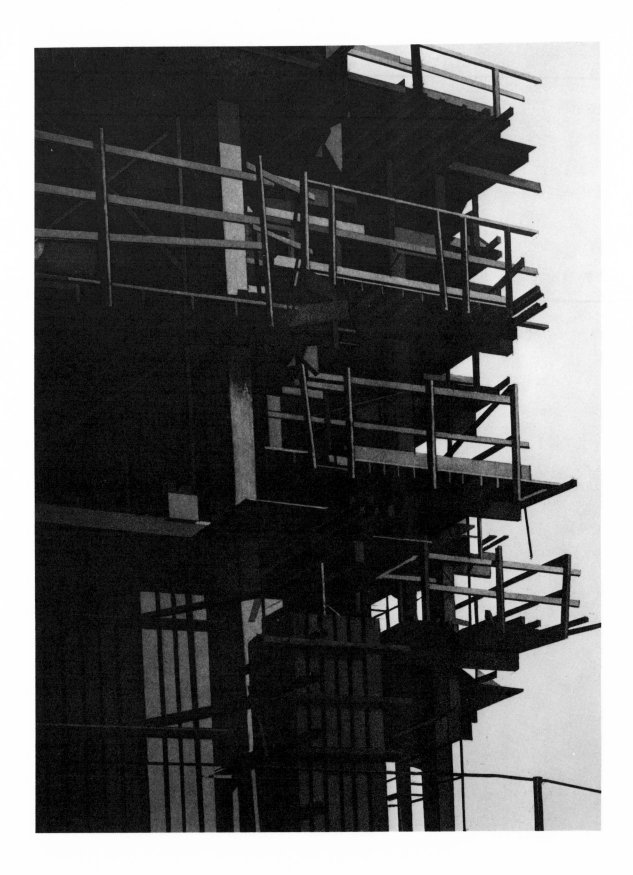

44

Crane

Intaglio, 1981, 12″ x 16″

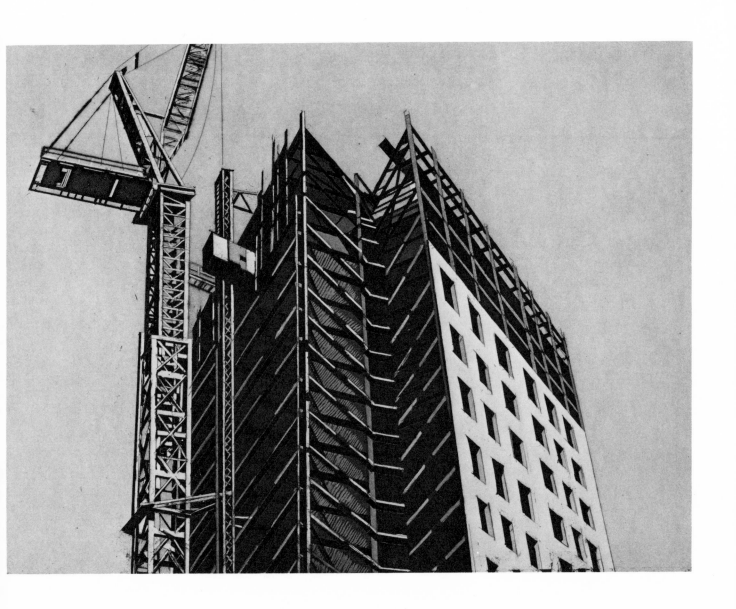

45

Sheathing

Intaglio, 1981, 12″ x 16″

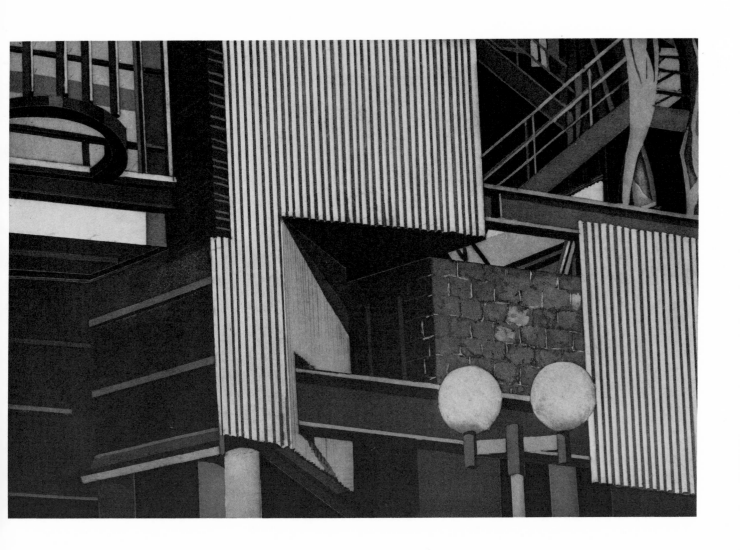

46

Superstructure

Intaglio, 1981, 12″ x 18″

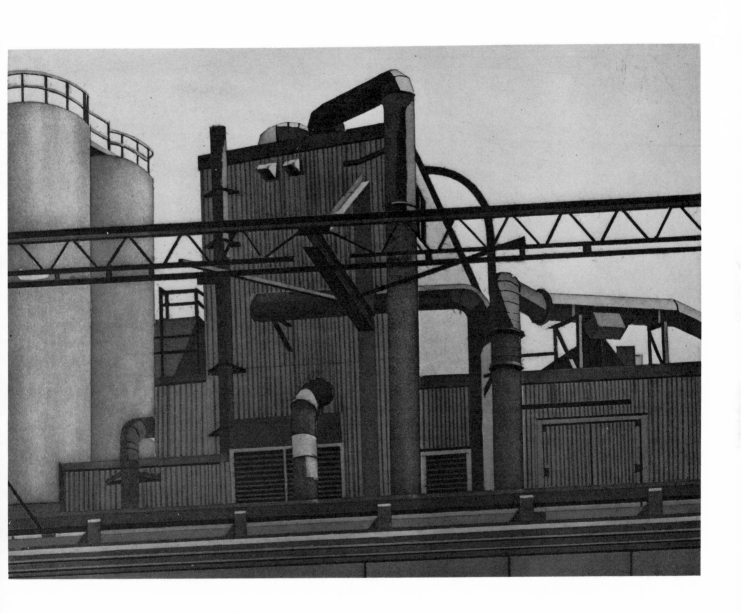

47

Skylights

Intaglio, 1981, 12″ x 16″

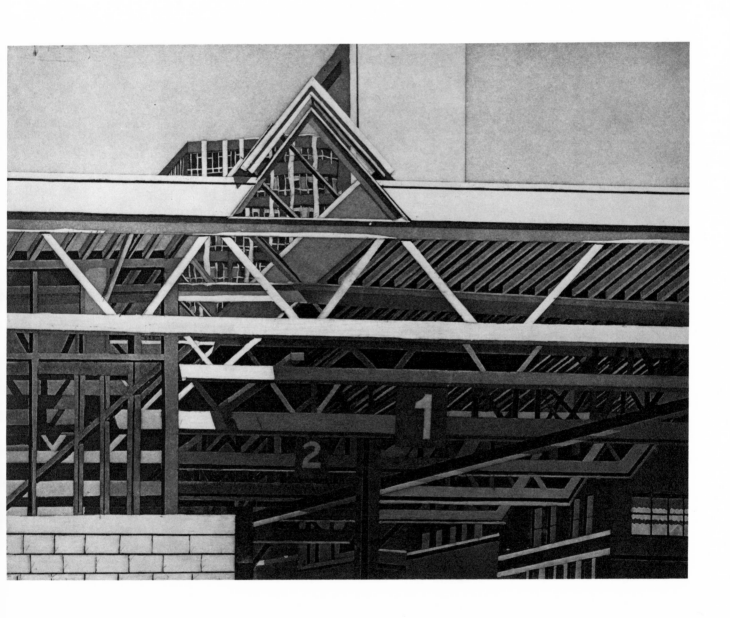

48

Grand Rapids

Intaglio, 1981, 18″ x 24″

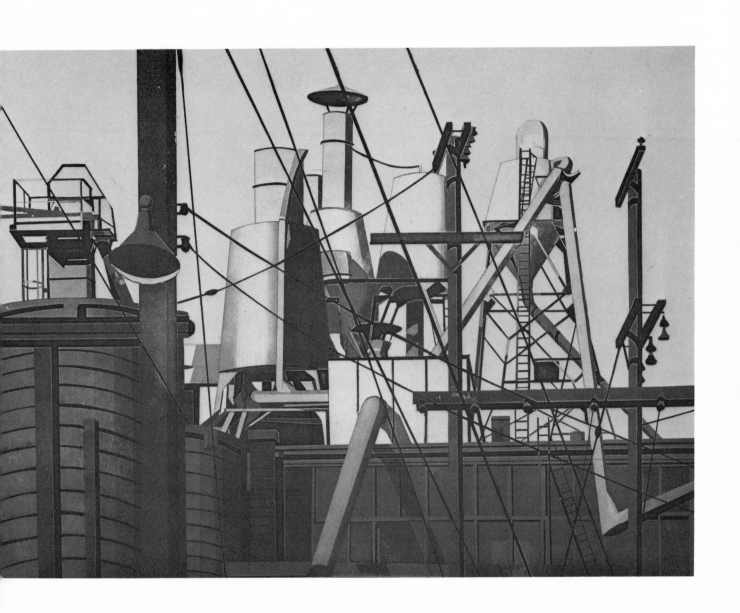

49

Black Facade
Intaglio, 1981, 18″ x 24″

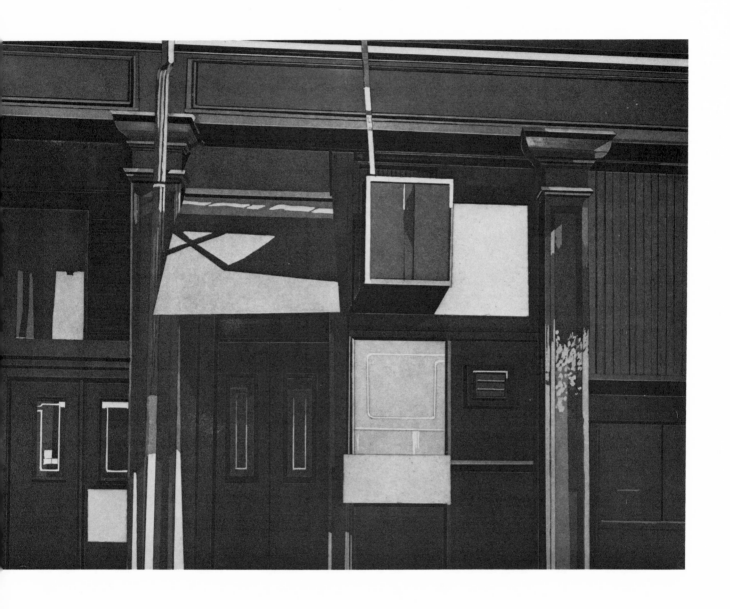

50

Stacks

Intaglio, 1983, 13″ x 18″

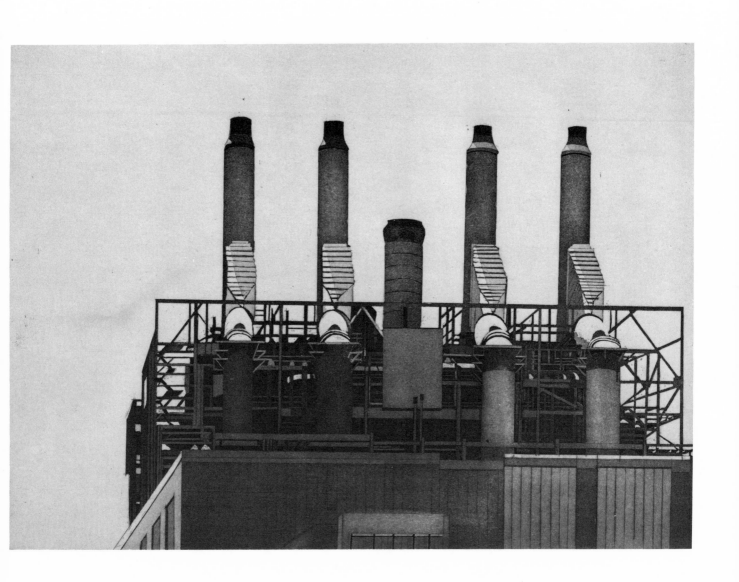

51

Coupling

Intaglio, 1981, 18″ x 20″

I was interested in the large simple forms of the railway cars joined in an almost symmetrical fashion by the complex coupling mechanism.

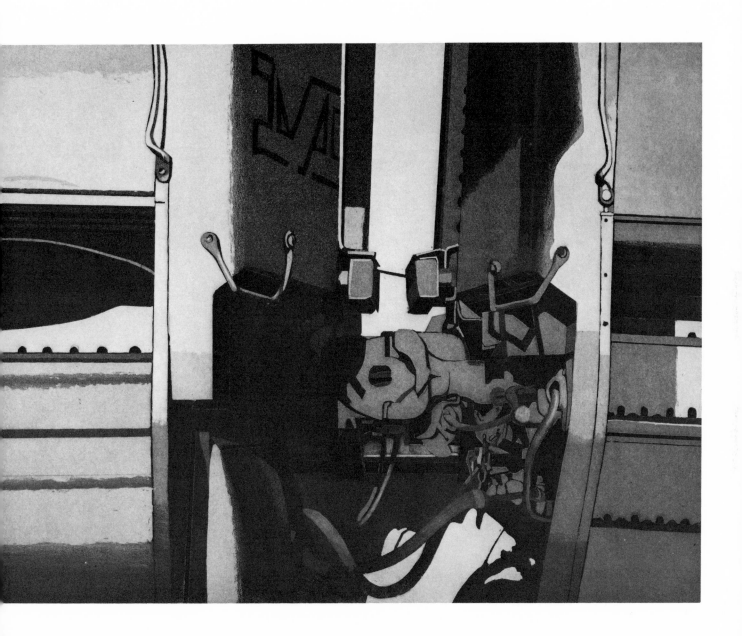

52

Quarry

Intaglio, 1983, 18″ x 24″

I discovered this massive rock-crushing machine in a disused quarry in southeastern Massachusetts.

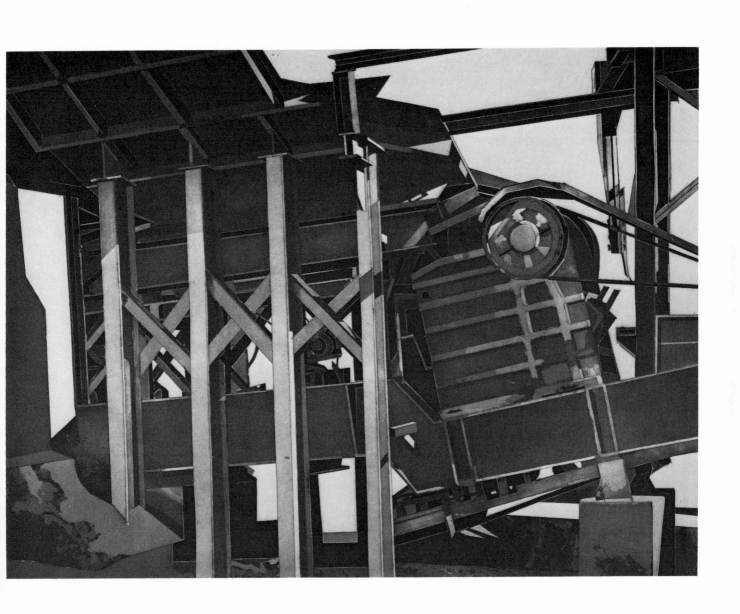

53

Concrete Plant

Intaglio, 1981, 24″ x 18″

This print and plates 54 and 55 are examples of two sand and gravel installations similar in function but varied in form. The wonderful complexity of the storage tanks, conveyer belts, supports, etc. suggest the architecture of fantastic castles or amusement park rides.

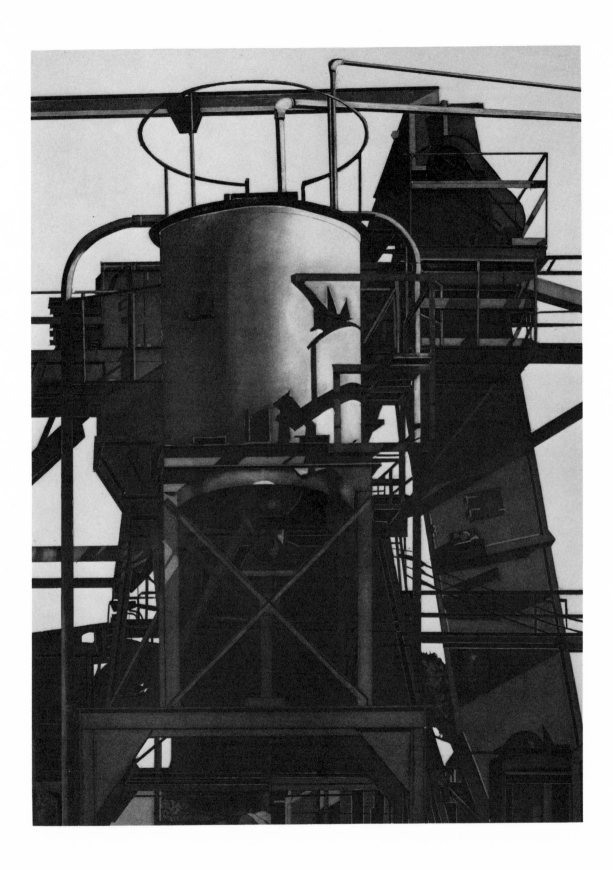

54

Weymouth I

Intaglio, 1983, 20″ x 18″

Plates 54 and 55 are two versions of the same structure.

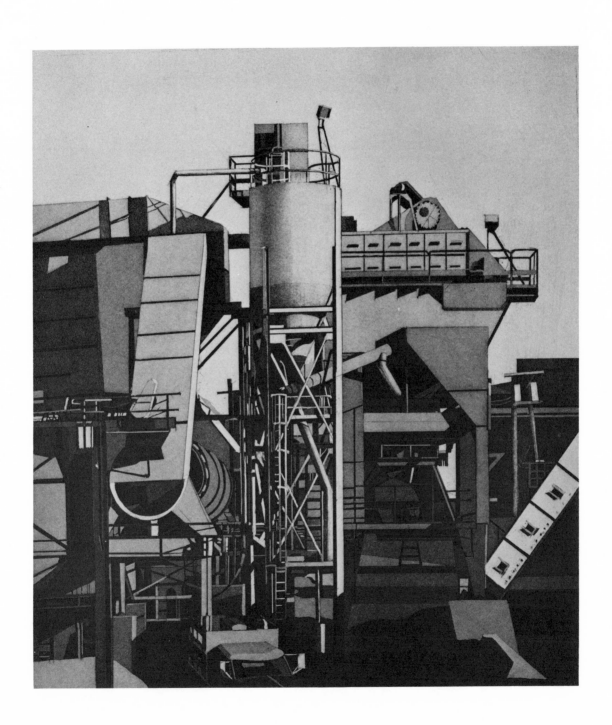

55

Weymouth II
Intaglio, 1983, 14″ x 18″

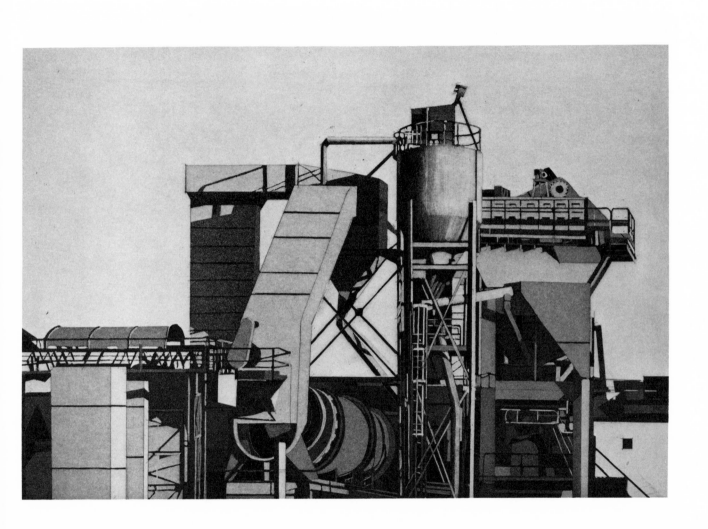

56

Barns, Norfolk

Intaglio, 1983, 18″ x 24″

In 1982 after a trip to the Northeast coast of England I put aside my concern with industrial and urban forms to do a series of prints dealing with the landscape of that part of the English countryside—particularly the County of Norfolk. Plates 56 through 60 are the result of that series. The impressions were hand-colored after printing.

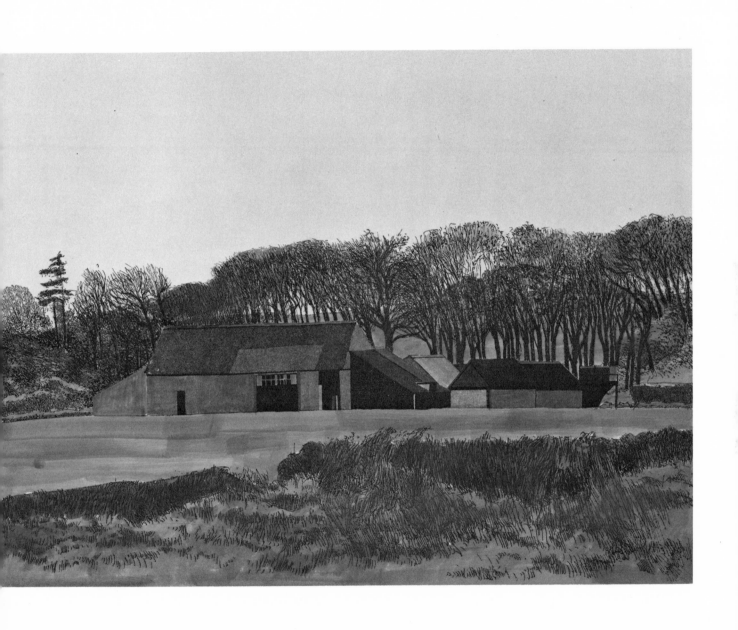

57

Church, Norfolk

Intaglio, 1983, 18″ x 24″

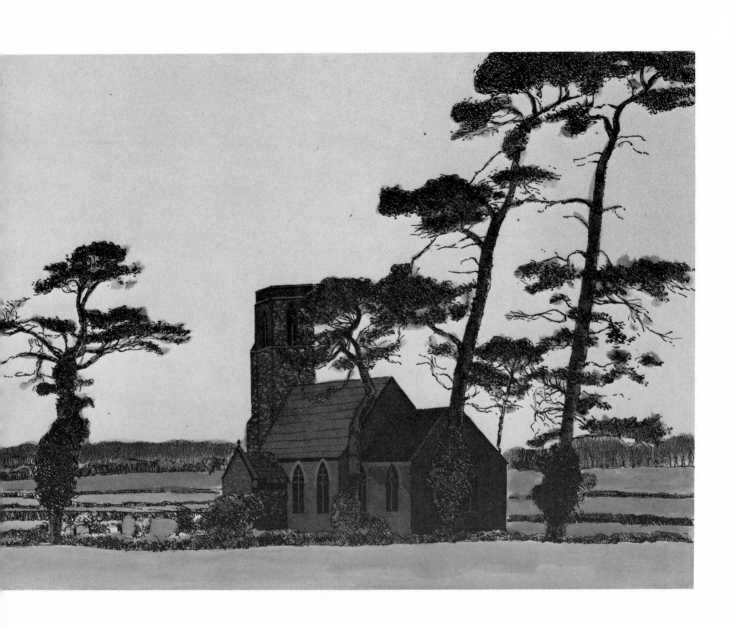

58

Near Burnham, Norfolk
Intaglio, 1983, 18″ x 24″

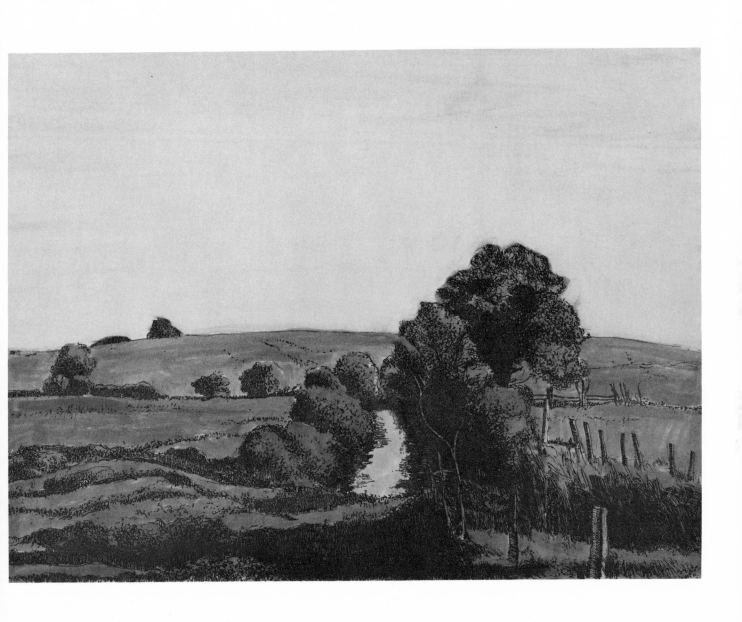

59

Three Trees, Norfolk

Intaglio, 1983, 18″ x 24″

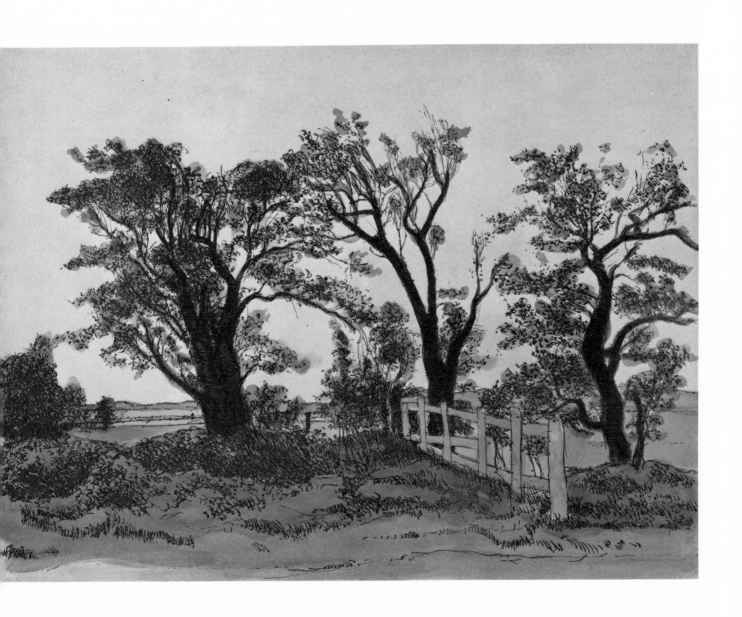

60

Yellow Field, Norfolk

Intaglio, 1983, 18″ x 24″

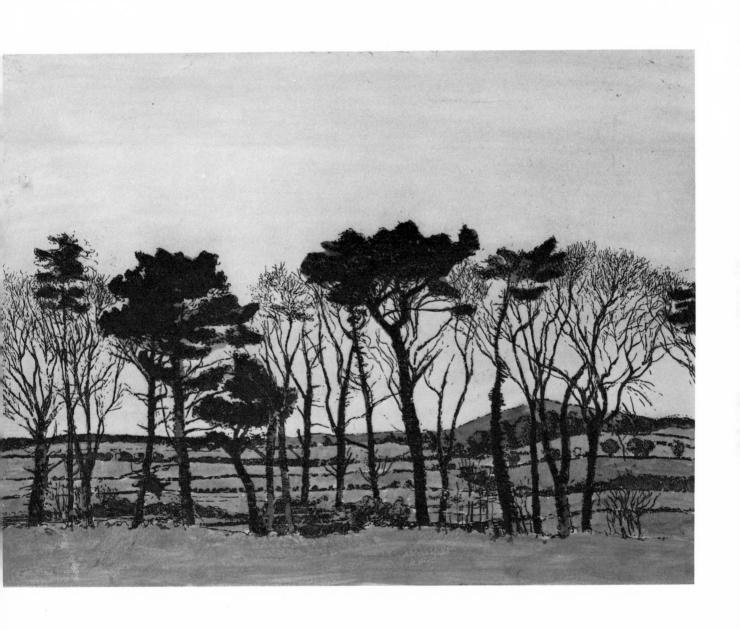

61

Lungarno Soderini, Florence

Intaglio, 1983, 18″ x 24″

Plates 61 and 62 were the result of time spent in Florence during the summers of 1979, 1980. The geometric forms of Florentine architecture echoed some of the industrial imagery in my earlier prints.

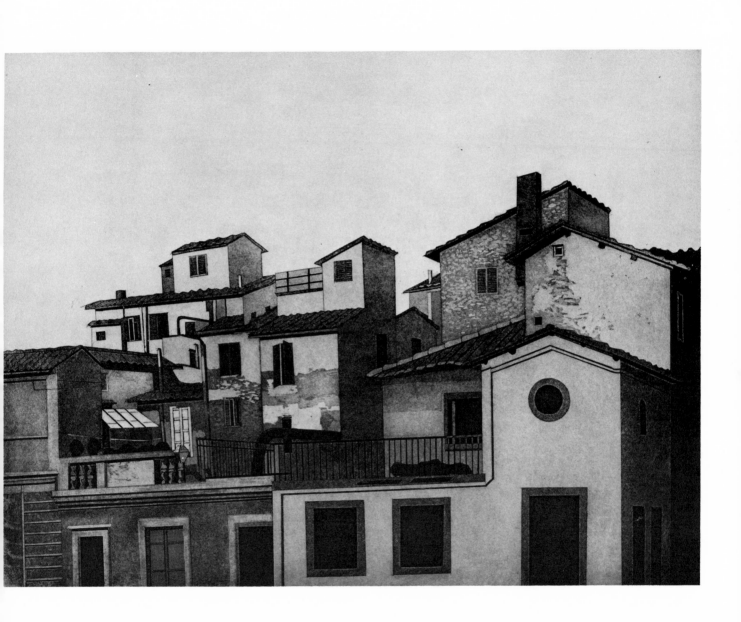

62

San Frediano, Florence
Intaglio, 1983, 18″ x 26″

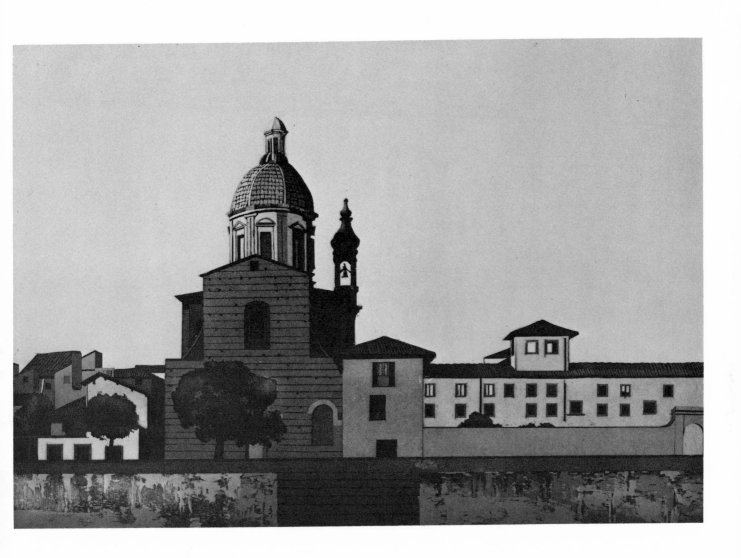

63

Rooftops

Intaglio, 1982, 18″ x 22″

This plate and plates 64 through 68 show prints concerned with urban architecture seen from elevated perspective and repeating the rooftop themes.

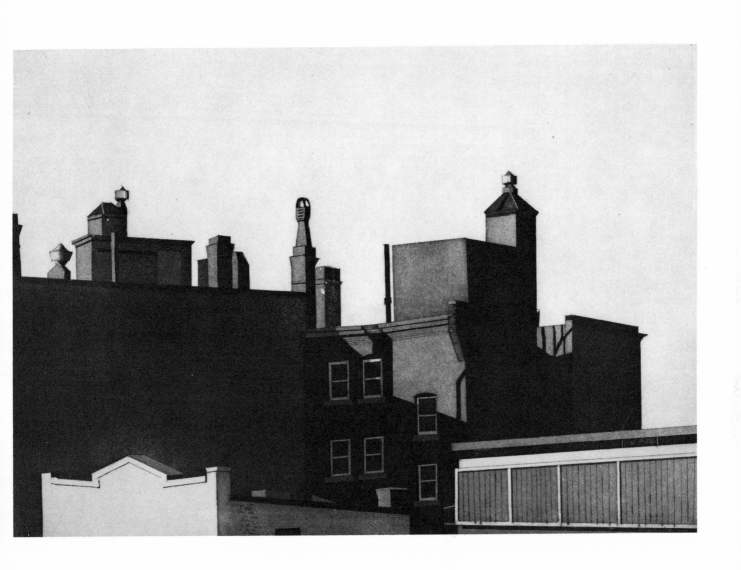

64

Station Street
Intaglio, 1983, 18″ x 22″

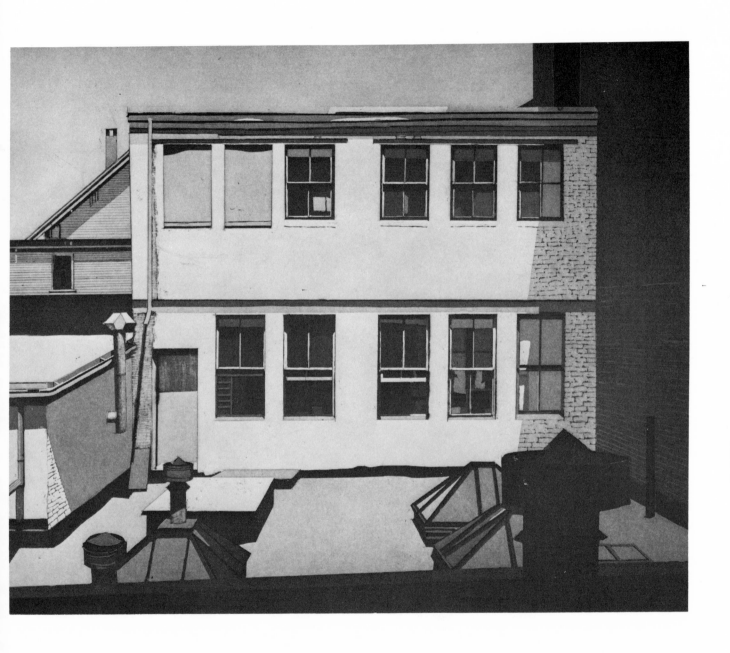

65

Rooftops, Chimneys

Intaglio, 1983, 16″ x 20″

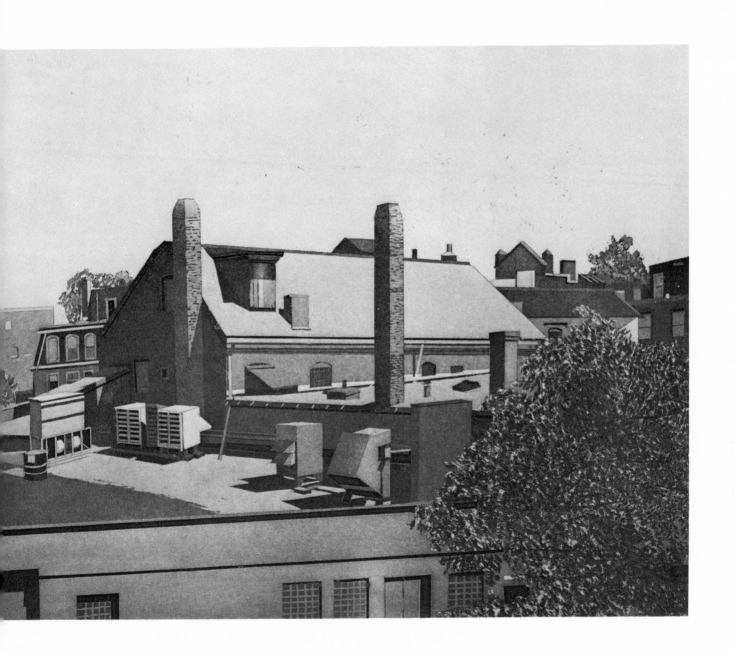

66

Roofscape, New York
Intaglio, 1984, 18″ x 24″

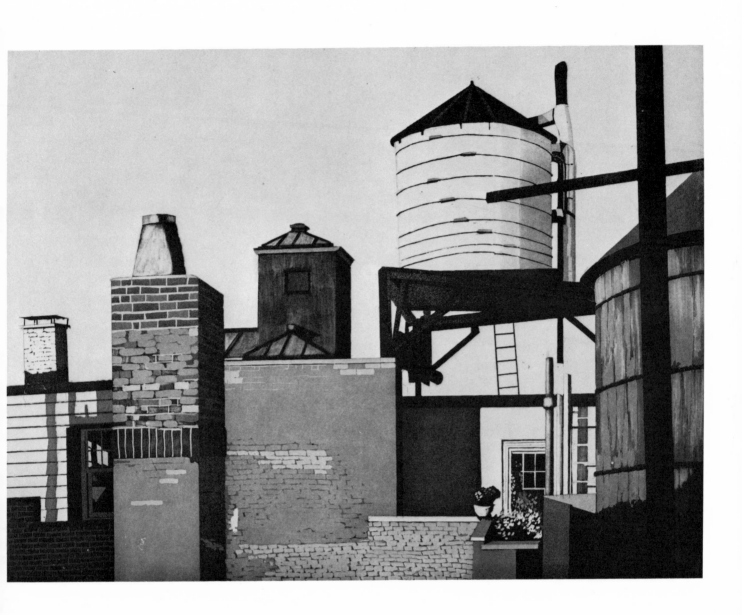

67

Roofscape, Water Tank
Intaglio, 1984, 14″ x 12″

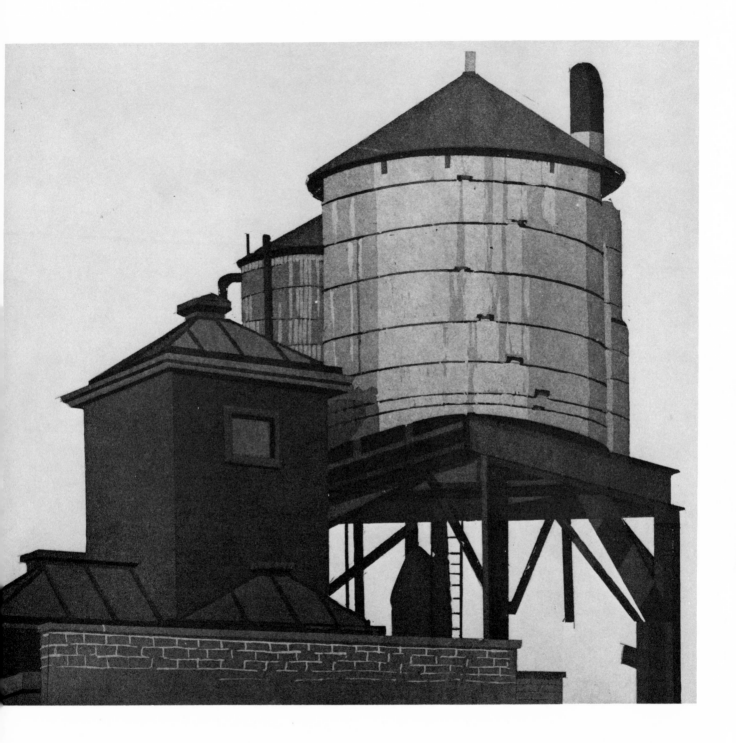

68

Roofscape, New York II
Intaglio, 1984, 18″ x 24″

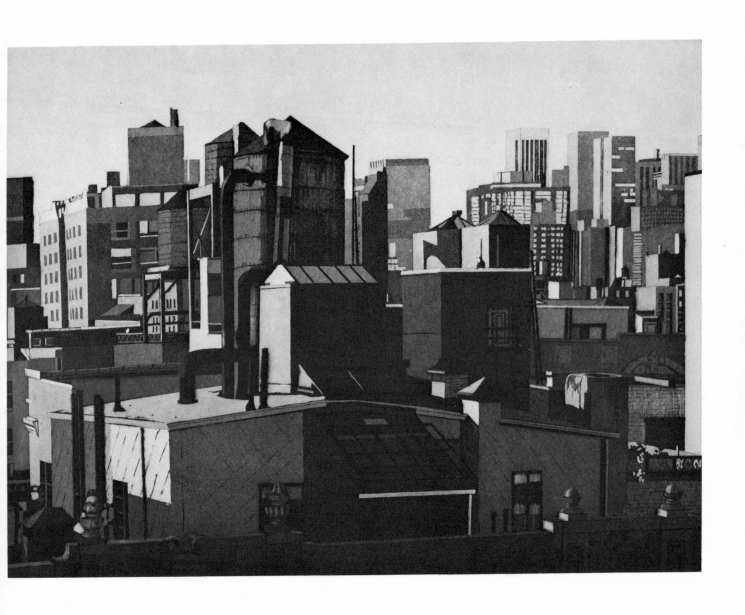

69

Brooklyn Bridge Arches
Intaglio, 1984, 24″ x 18″

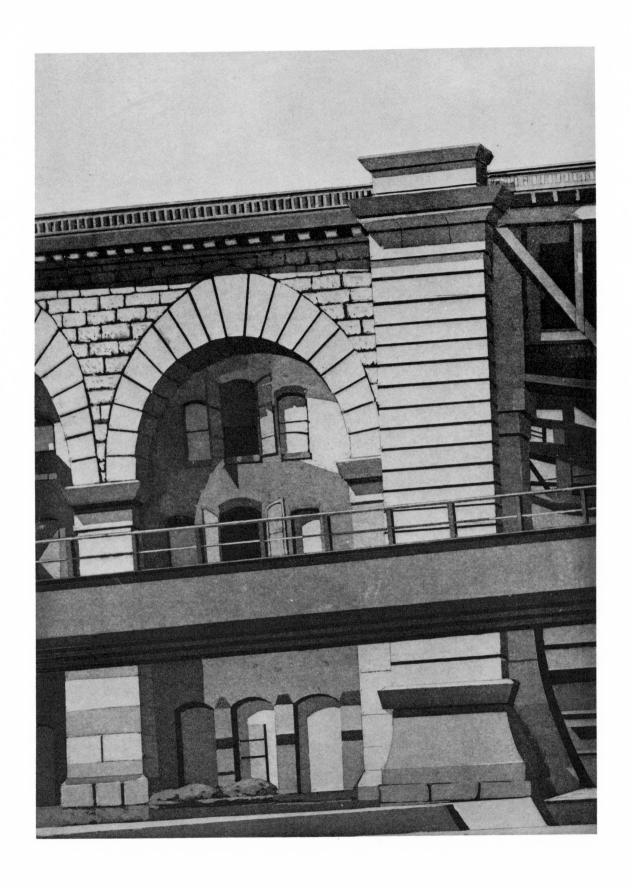

70

Storage Tanks

Intaglio, 1977, 18″ x 20″

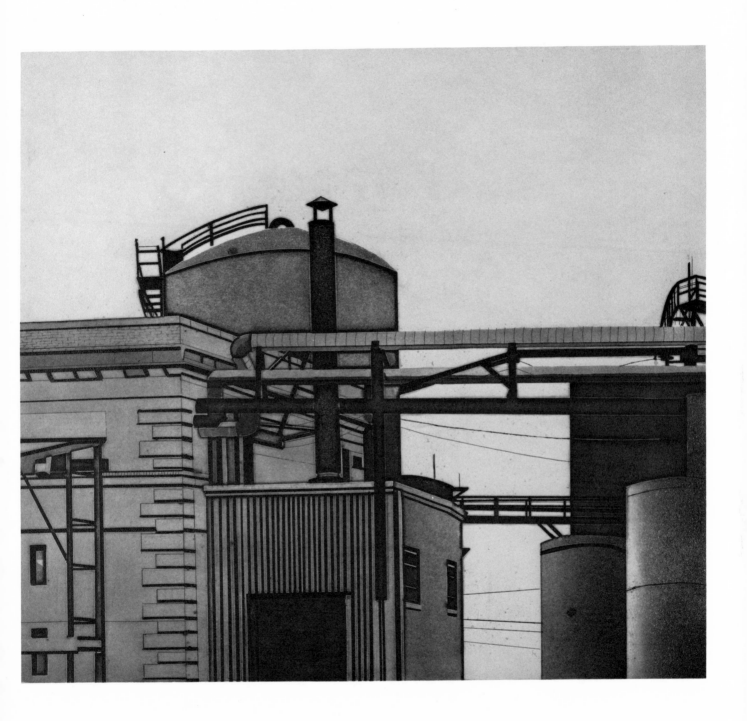

About the Artist

SIDNEY HURWITZ was born in Worcester, Massachusetts in 1932. He attended the School of the Worcester Art Museum where he studied with Leonard Baskin and Herbert Barnett. He received a B.A. from Brandeis University working with Mitchell Siporin and Peter Grippe and an M.F.A. from Boston University where he worked with David Aronson, Reed Kay, and Jack Kramer. Under a Fulbright Fellowship Sidney Hurwitz continued his studies at the Academy of Art in Stuttgart, Germany in 1960. He has received awards and fellowships from the Louis Comfort Tiffany Foundation, The National Institute of Arts and Letters, and the Massachusetts Artists Foundation.

Hurwitz has had one-man exhibitions at Amerika Haus, Freiburg, Germany; Fitchburg (Massachusetts) Art Museum; Clark University; Newport (Rhode Island) Art Museum; Martin Sumers Gallery, New York; Mary Ryan Gallery, New York; Oxford Gallery, Oxford, England.

His work is in the permanent collections of the Library of Congress, Museum of Modern Art, Philadelphia Library, U.S. Department of State, Boston Public Library, Federal Reserve Bank of Boston, Norfolk (Virginia) Museum, University of Massachusetts, Victoria and Albert Museum, Japan International Bank, London, and many others.

Sidney Hurwitz has been on the faculties of Wellesley College, Skowhegan School of Painting and Sculpture, Brandeis University, and is now at Boston University where he is Professor of Art.